中國畫冊

吳學瑞作

目录 CONTENTS

作者自述/Author Bio　　　　　　　　　　　　　　　　　i

第一章/Chapter 1 岁岁大吉 (Rooster)　　　　　　　　　Pg 1

第二章/Chapter 2 雄鹰展翅 (Eagle)　　　　　　　　　　Pg 6

第三章/Chapter 3 鸟语花香 (Bird and flower)　　　　　Pg 13

第四章/Chapter 4 虎虎生威 (Tiger)　　　　　　　　　　Pg 27

第五章/Chapter 5 一马平川(Horse)　　　　　　　　　　Pg 34

第六章/Chapter 6 大好河山(Mountain and valley)　　　Pg 38

编后语/Editor's note　　　　　　　　　　　　　　　　Pg 40

梦呓

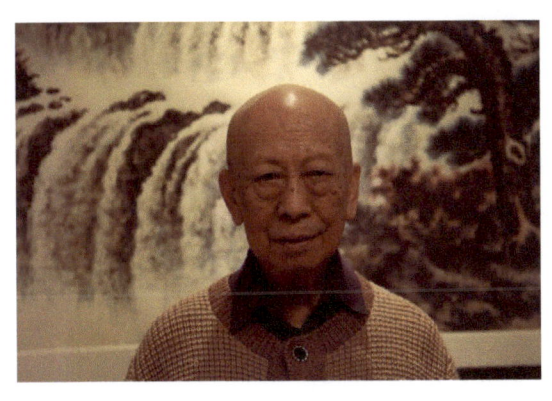

老翁年已八十有六，自幼酷爱中国书画。青山随季变，流水更无形，弯弯曲曲终年华。

离休之后重回头，颤手重温笔墨砚。进入老年大学学习，只为享受中国文化之锦美绵长和深厚，细品心尝慢咀嚼，浅识细微之门道。师从何镜涵、陈硕石、刘绍镛等著名画家后，更有了进一步的提高，对深远绵长悠久之中国画艺——写意画，方有更新层的领悟，正如郑板桥诗云"四十年来画竹枝……画到生时是熟时"。吾虽技艺不高，但孜孜不倦，勤耕细耘三十余载，只为心胸忽达、身心健康、延年益寿。而今方有所获，现奉献若干拙品，与朋友们共享学习之乐趣；与各界书画爱好者、孔子学院的同学们，共同探讨中国画艺之渊博与锦秀。

作者：吴学瑞

2017 年 4 月

AUTHOR BIO

I was born in 1932, and fell in love with Chinese painting as a child. My life has been like twists and turns of the mountain stream.

To deeply explore the beauty of Chinese culture, I re-entered college to study painting after retiring. Under the guidance of well-known painters Mr. Jinghan He, Mr. Shuoshi Chen, and Mr. Shaoyong Liu, my freehand brushworks improved gradually. As Poet Banqiao Zheng said: "After painting bamboos for forty years …… Feeling amateurish again when truly experienced." My painting skill still needs to be improved, and that keeps me practicing and exploring over 30 years. I would like to share my paintings with you - painting and calligraphy lovers, and Confucius Institute students, to explore the essence of Chinese painting.

Author: Xuerui Wu

2017-04

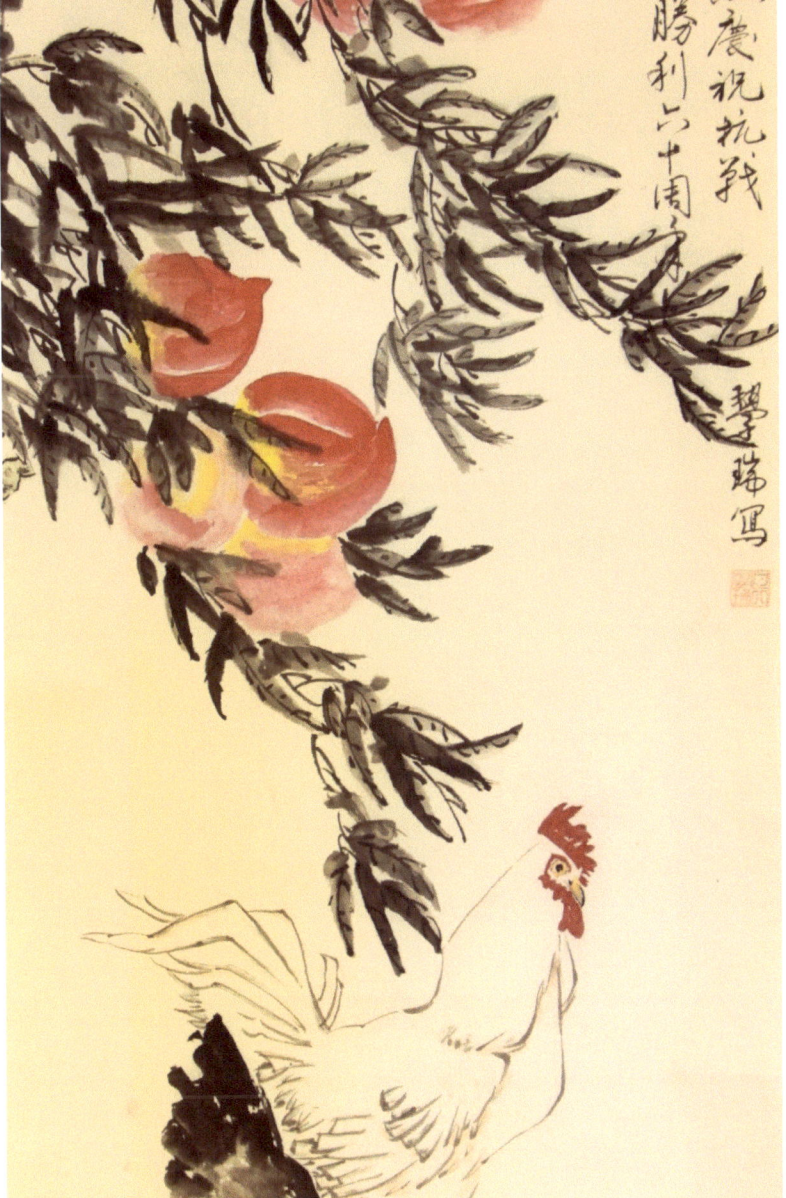

鸡画荟萃
------ *Rooster* ------

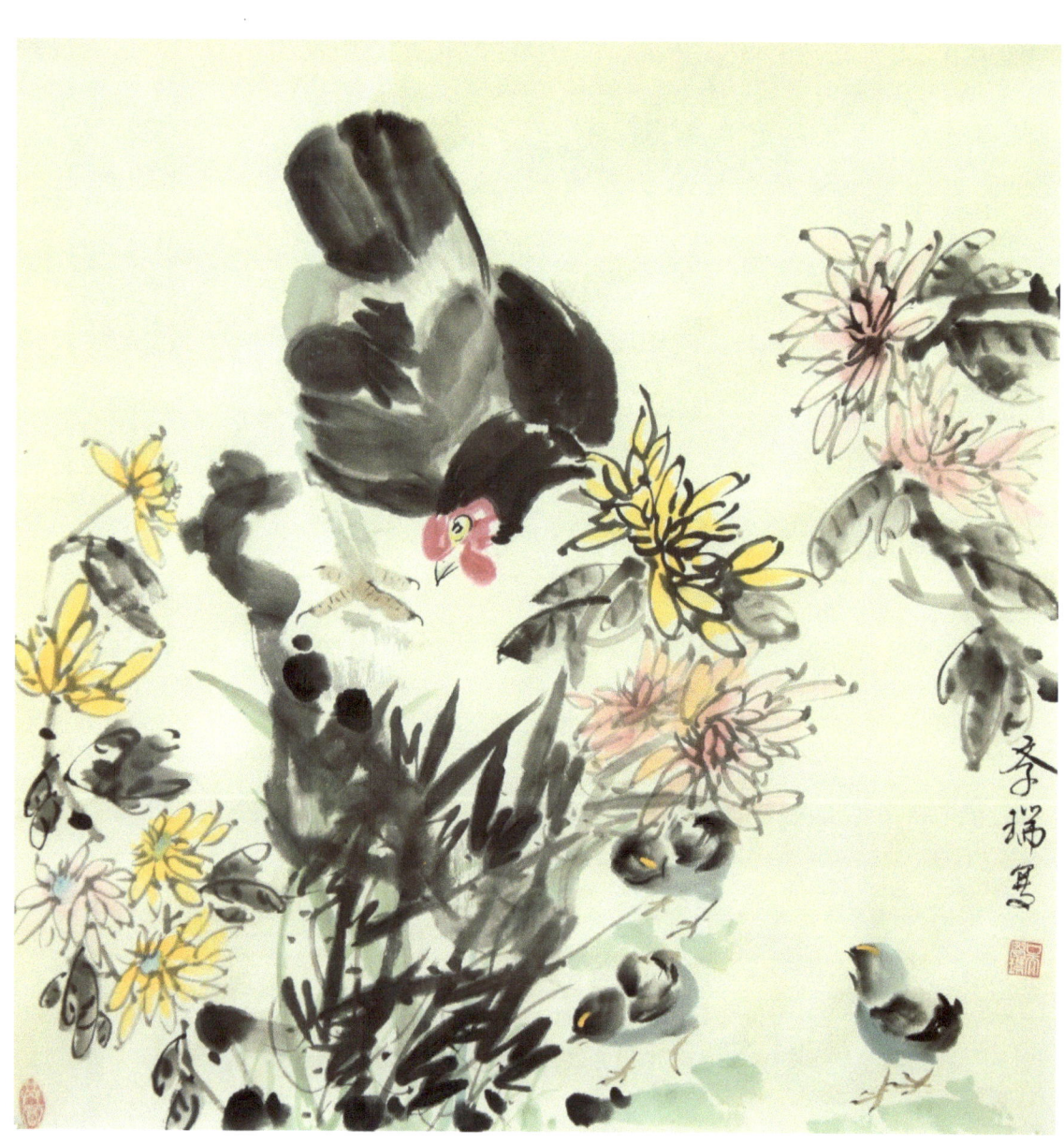

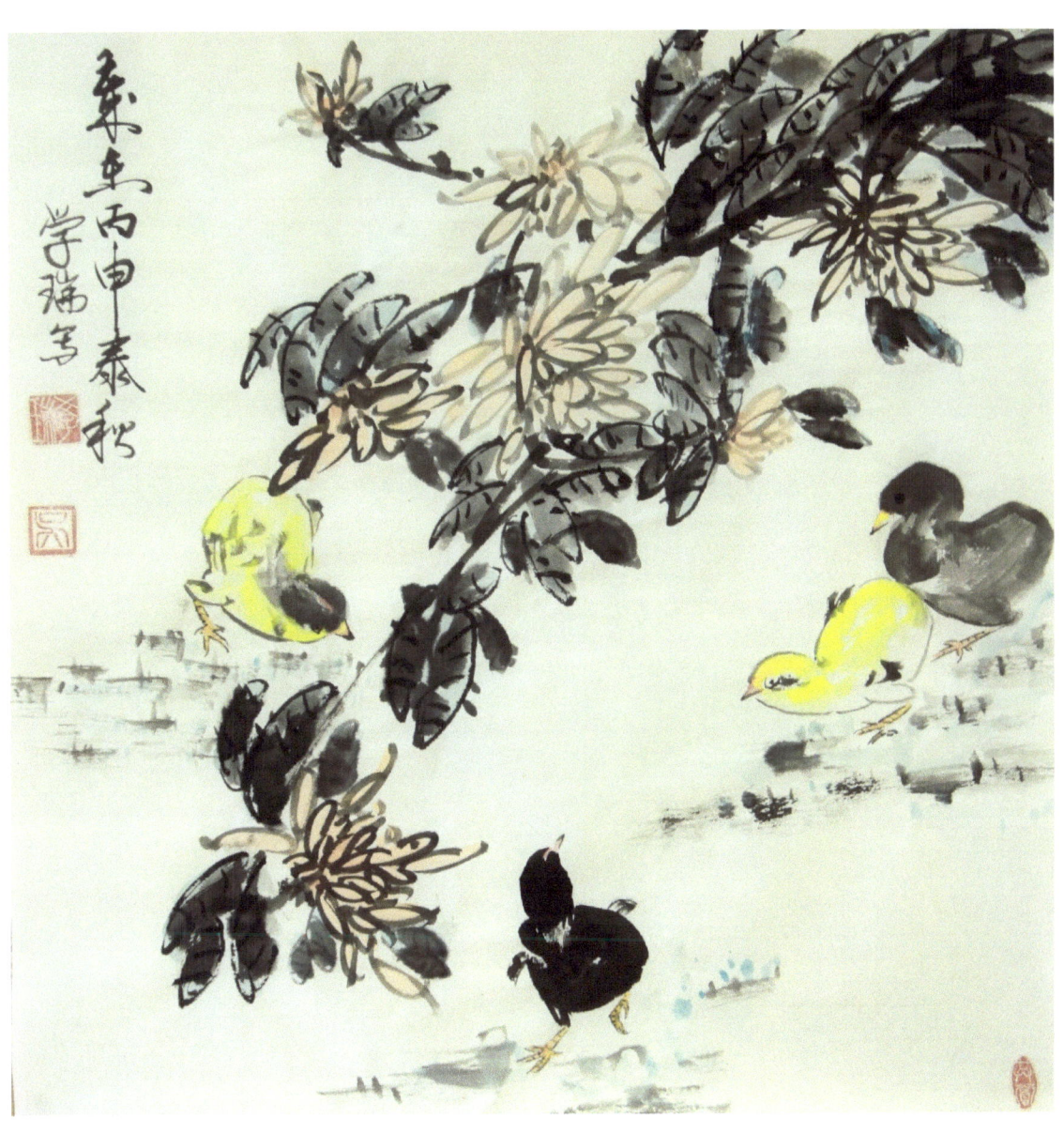

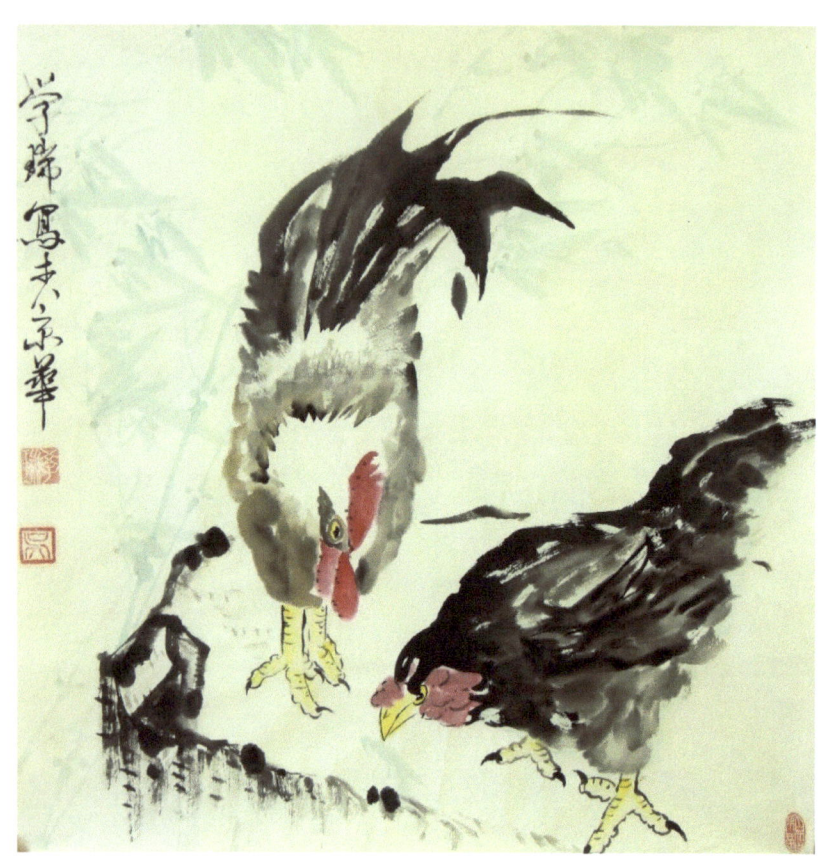
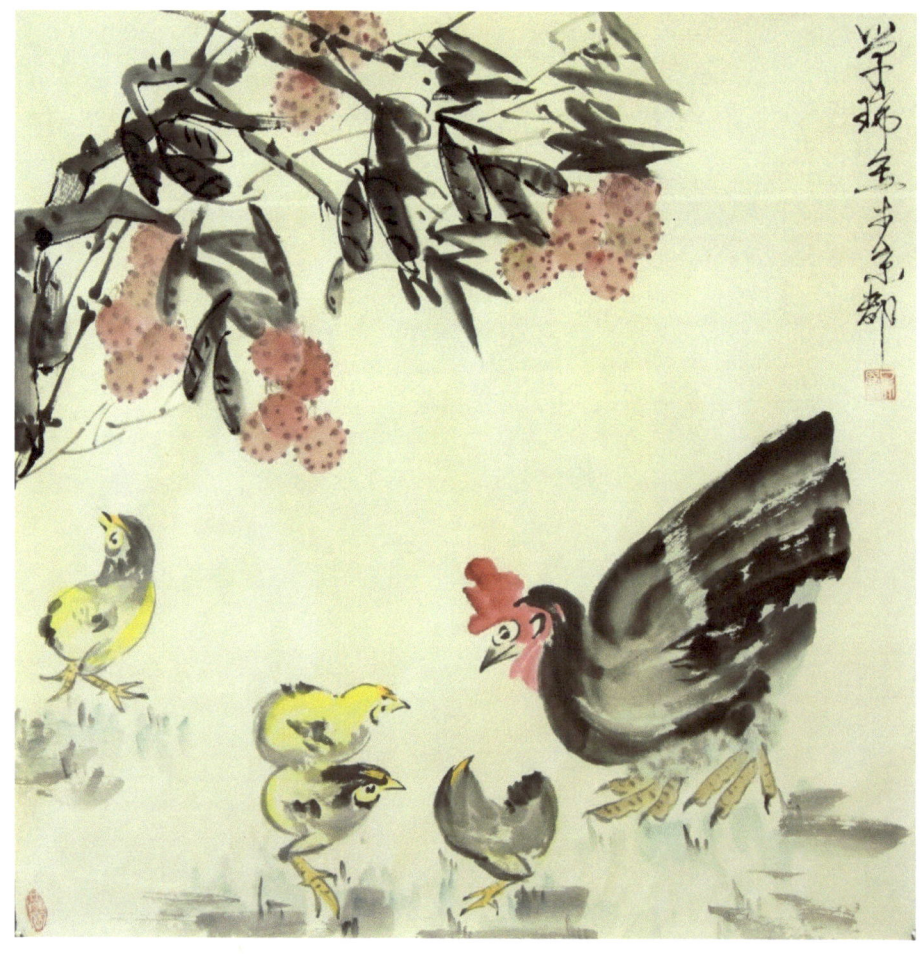

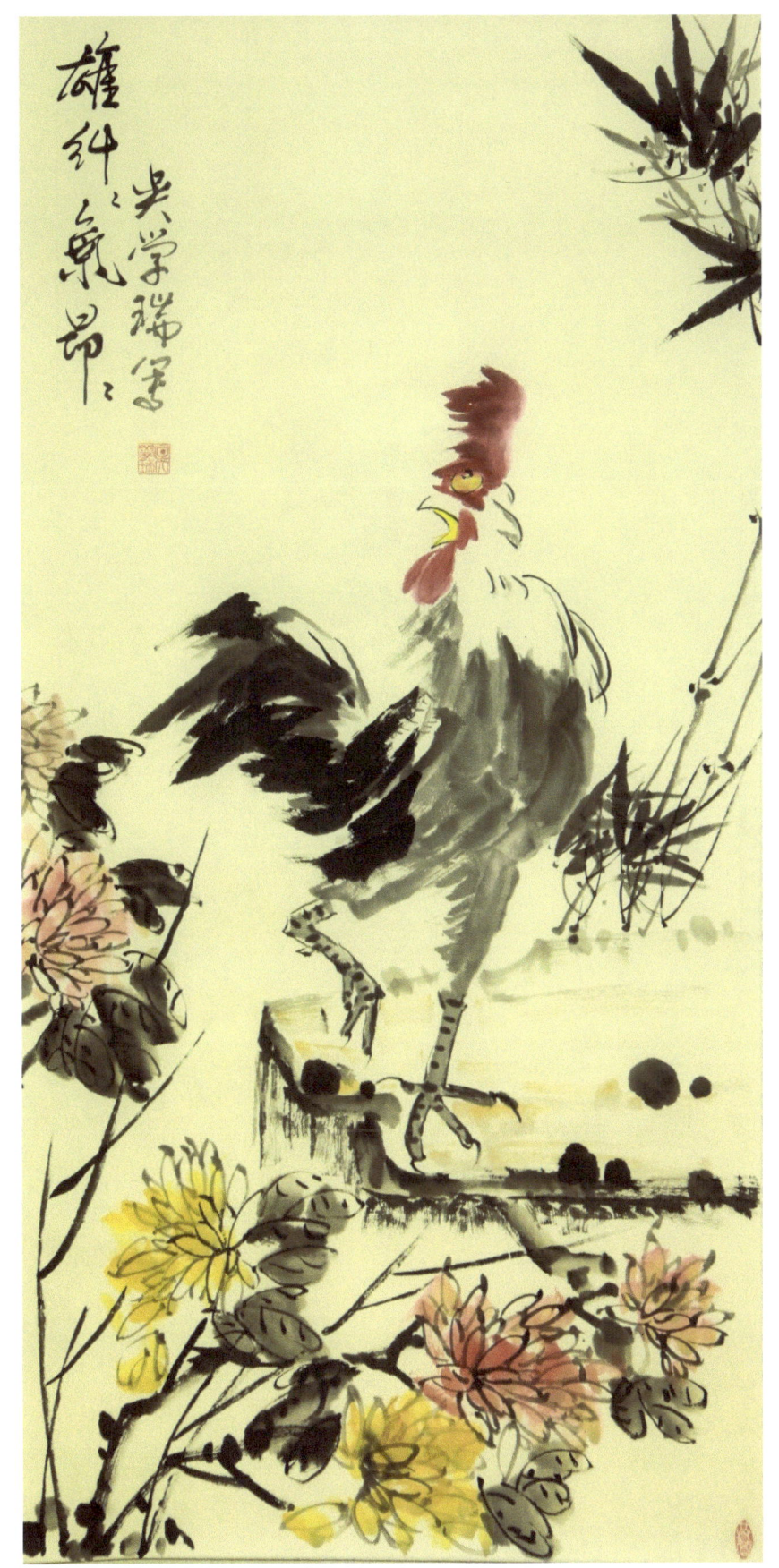

雄鹰展翅 —— *Eagle* ——

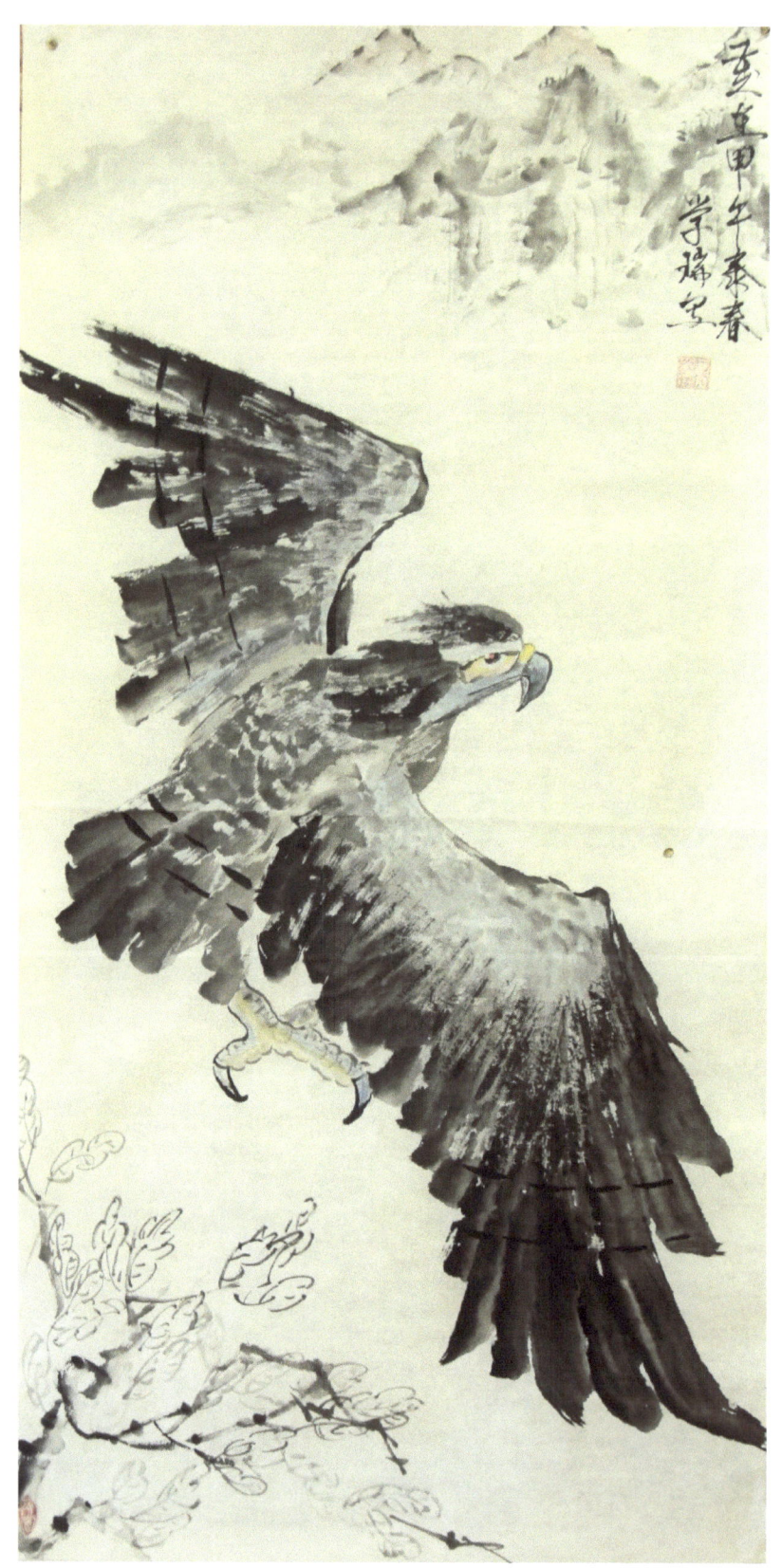

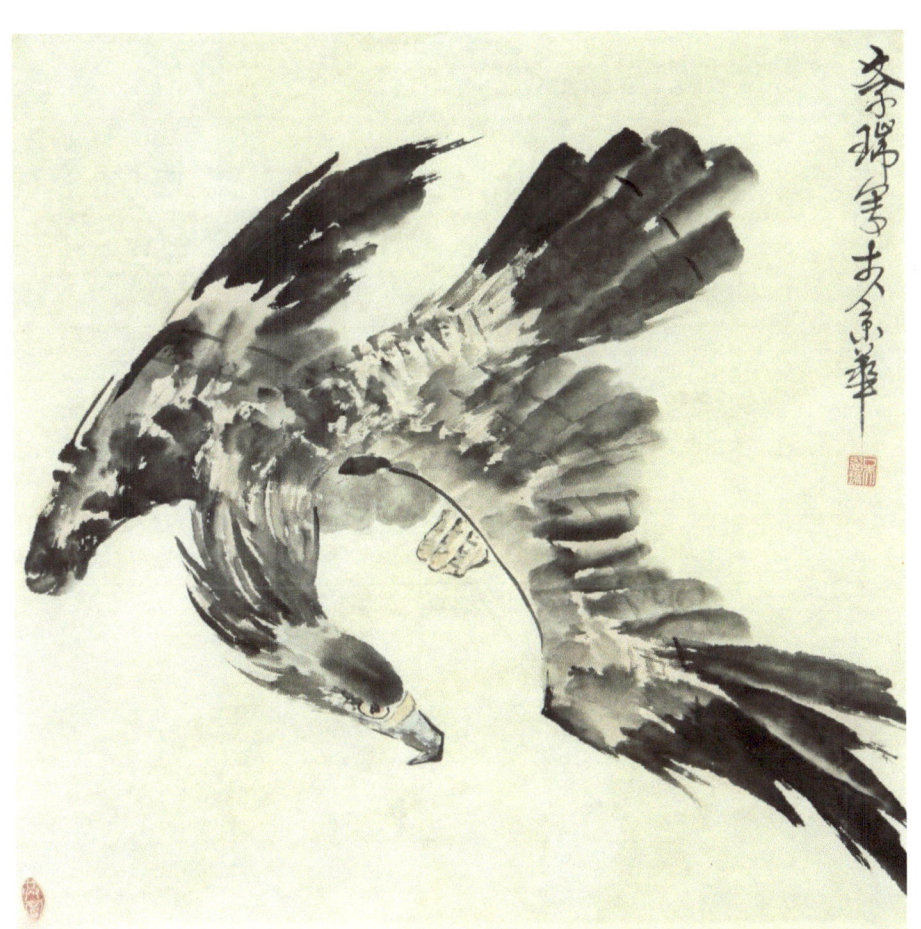

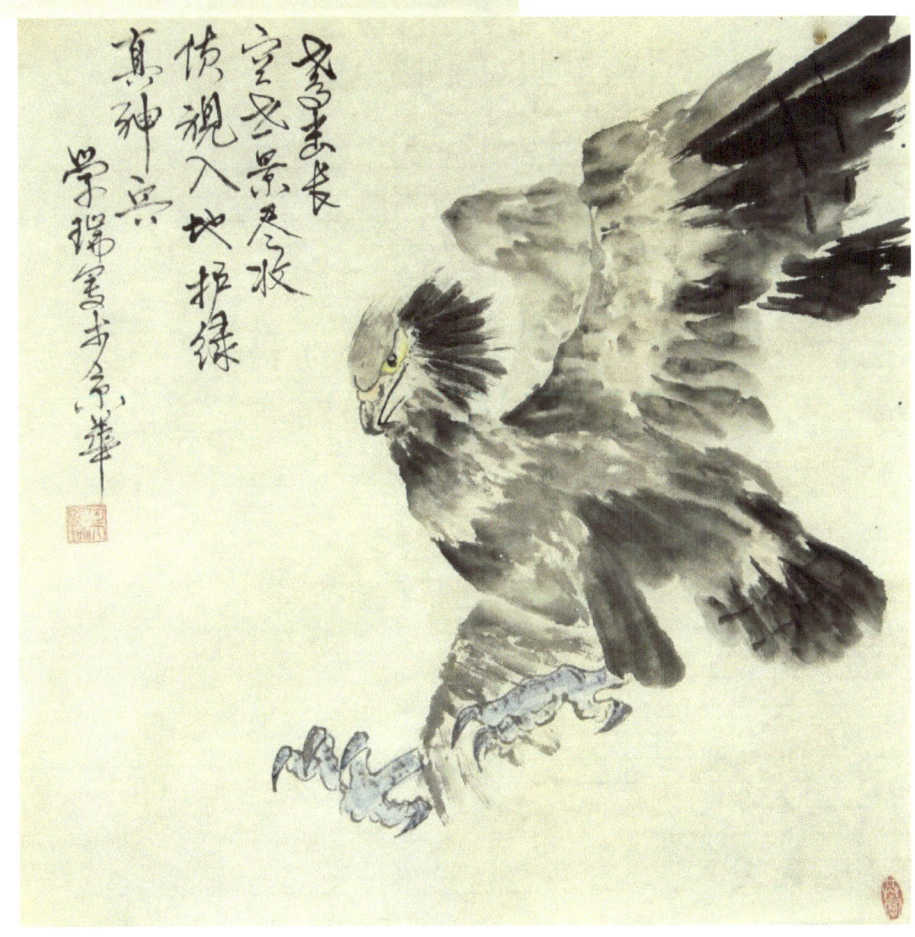

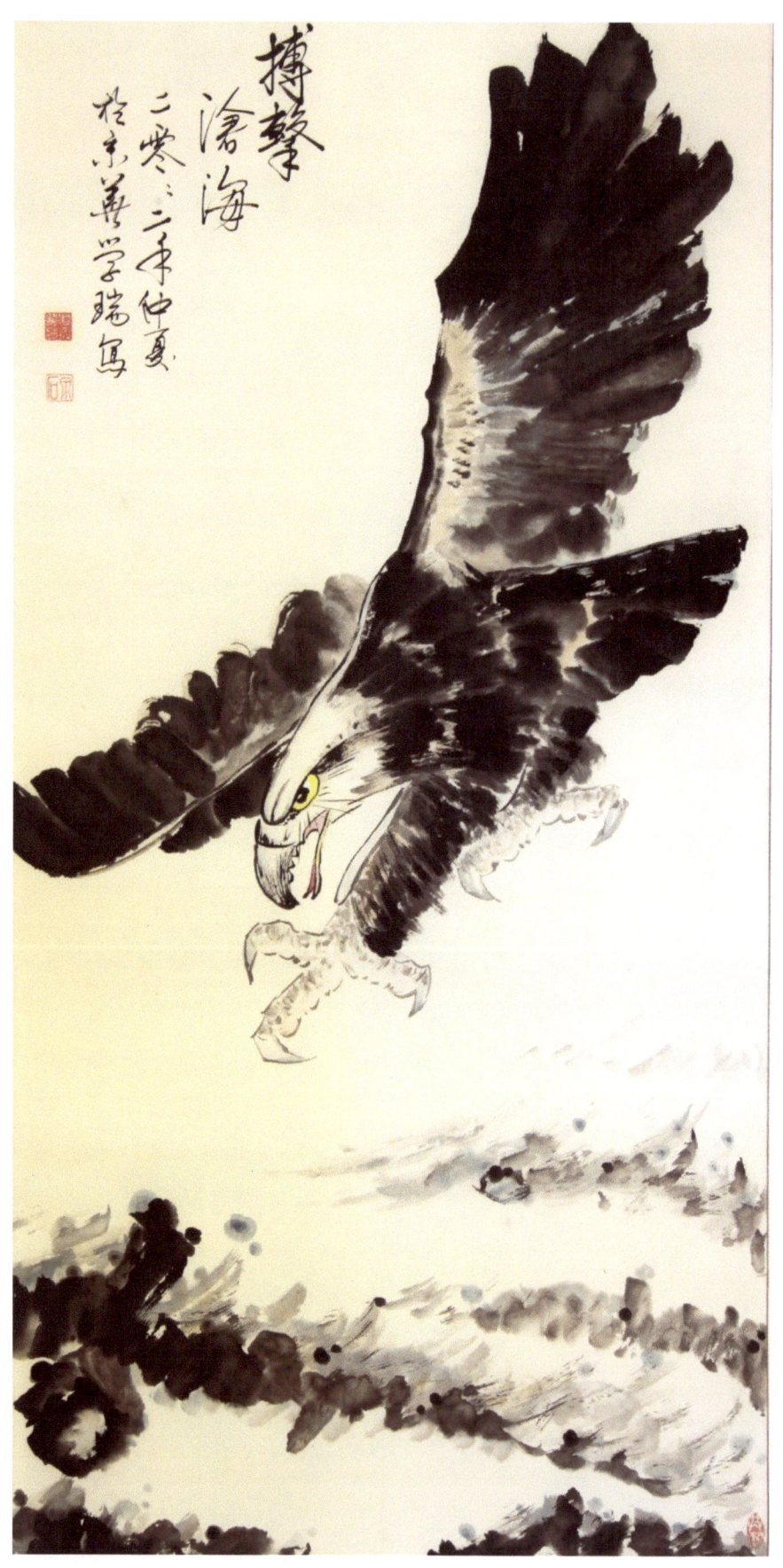

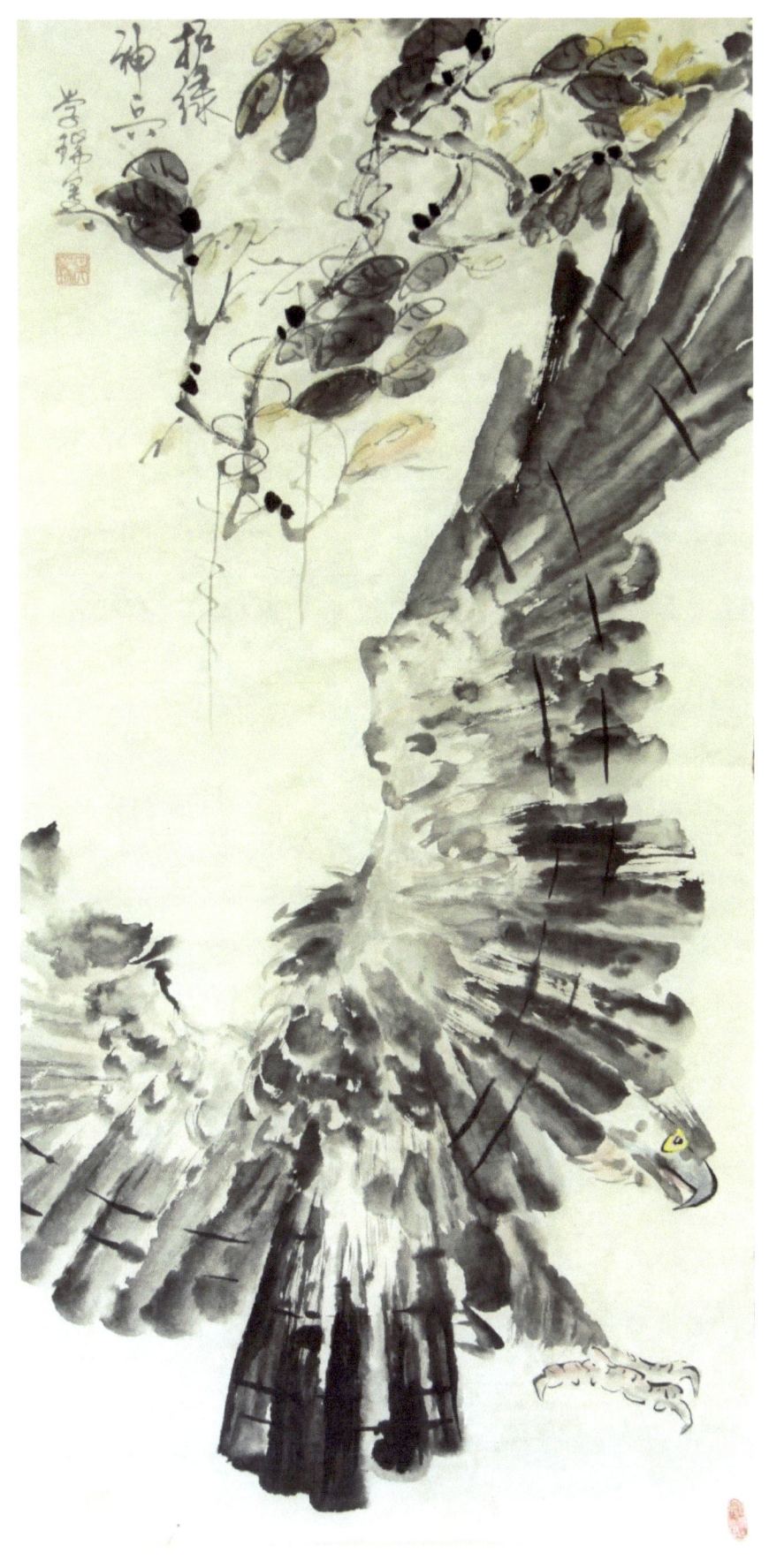

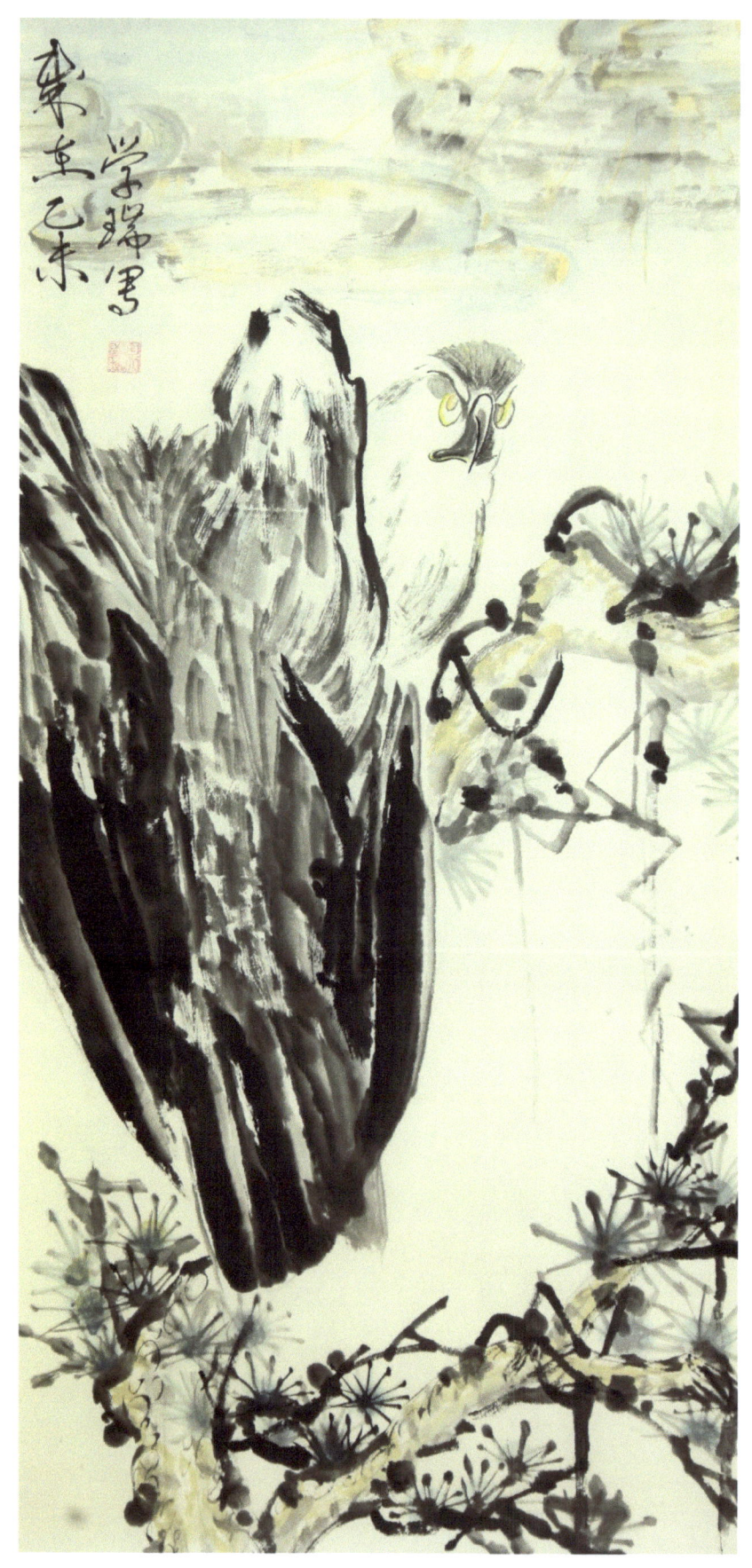

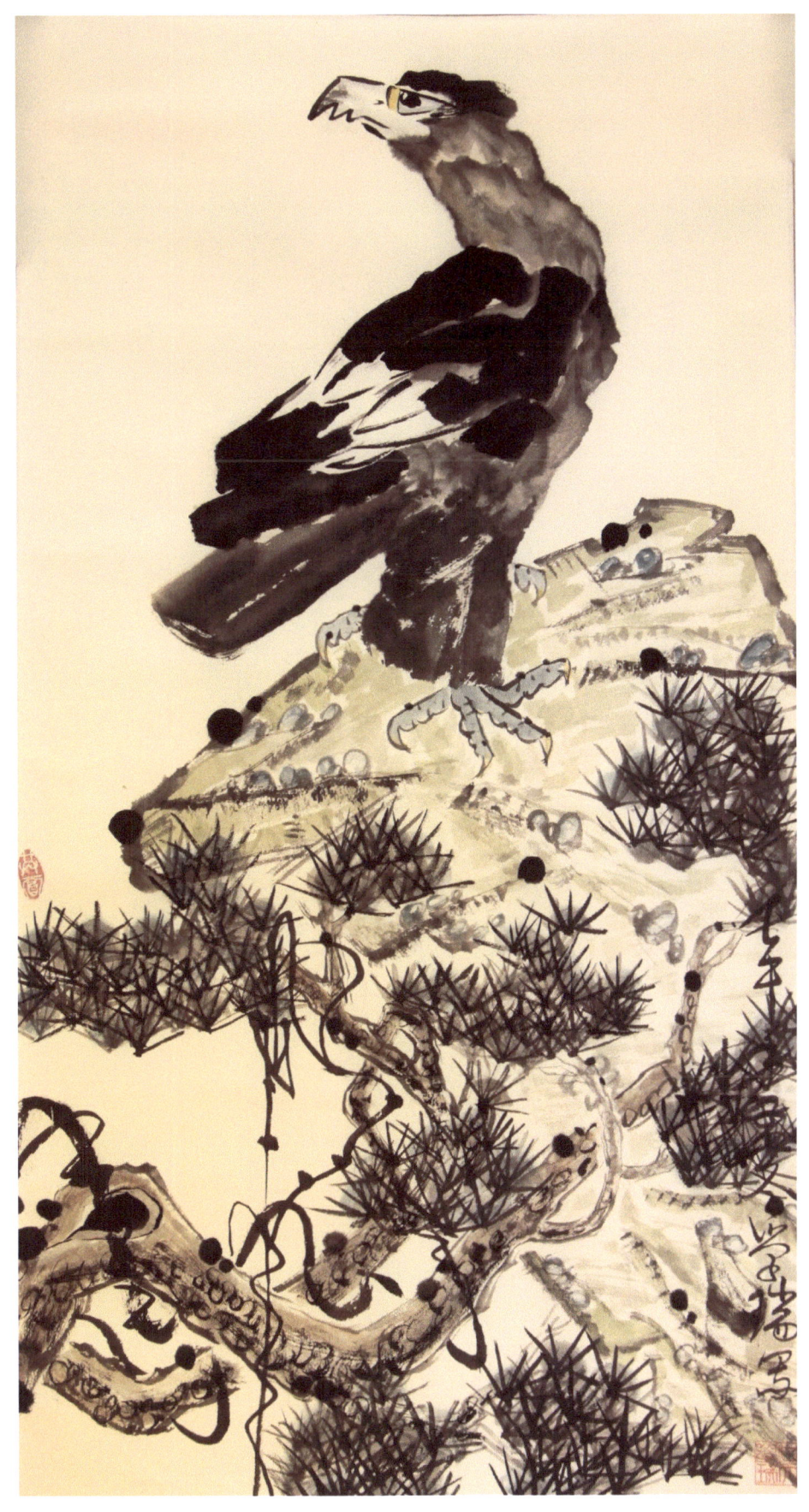

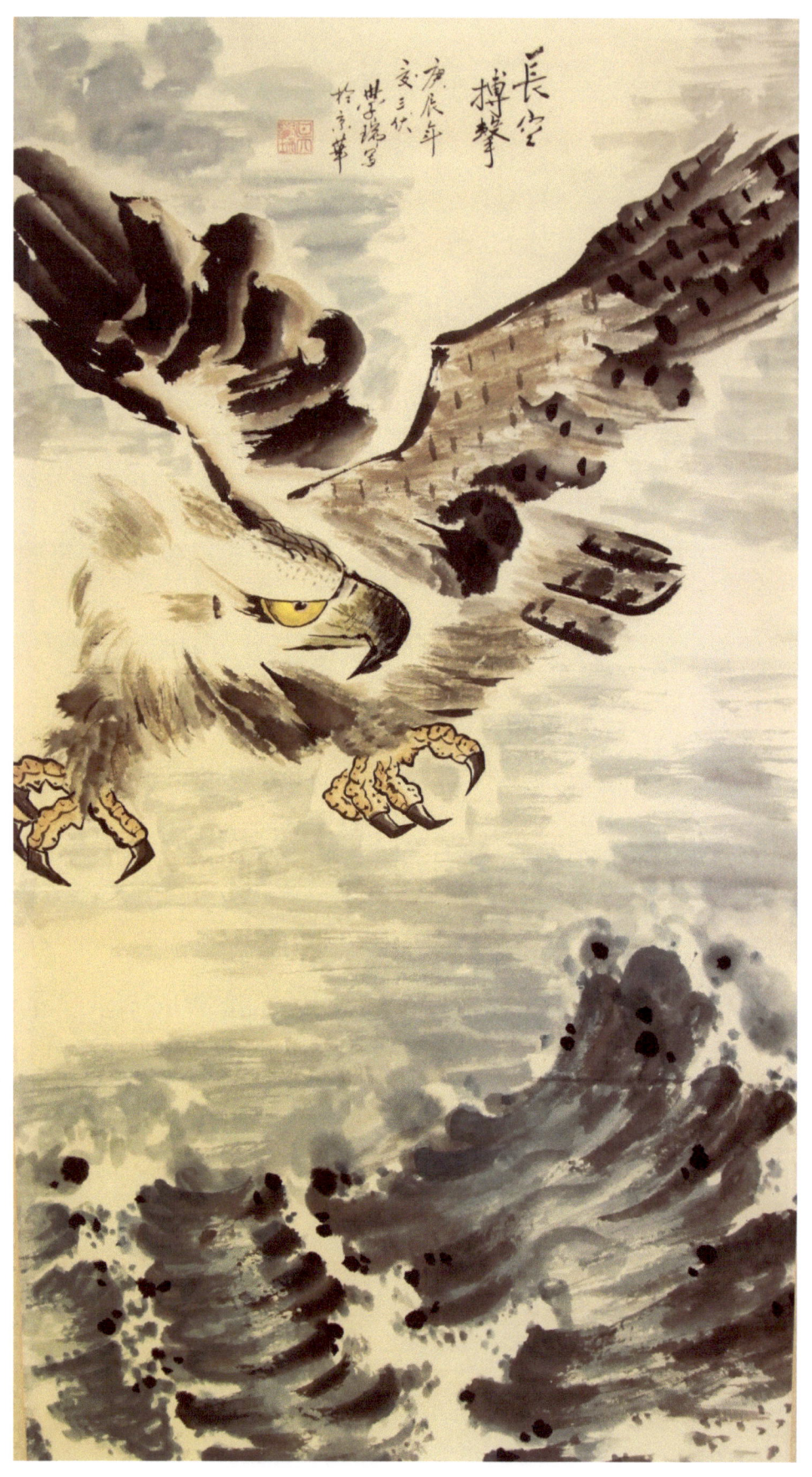

鸟语 ---- Bird ----

花香 ---- Flower ----

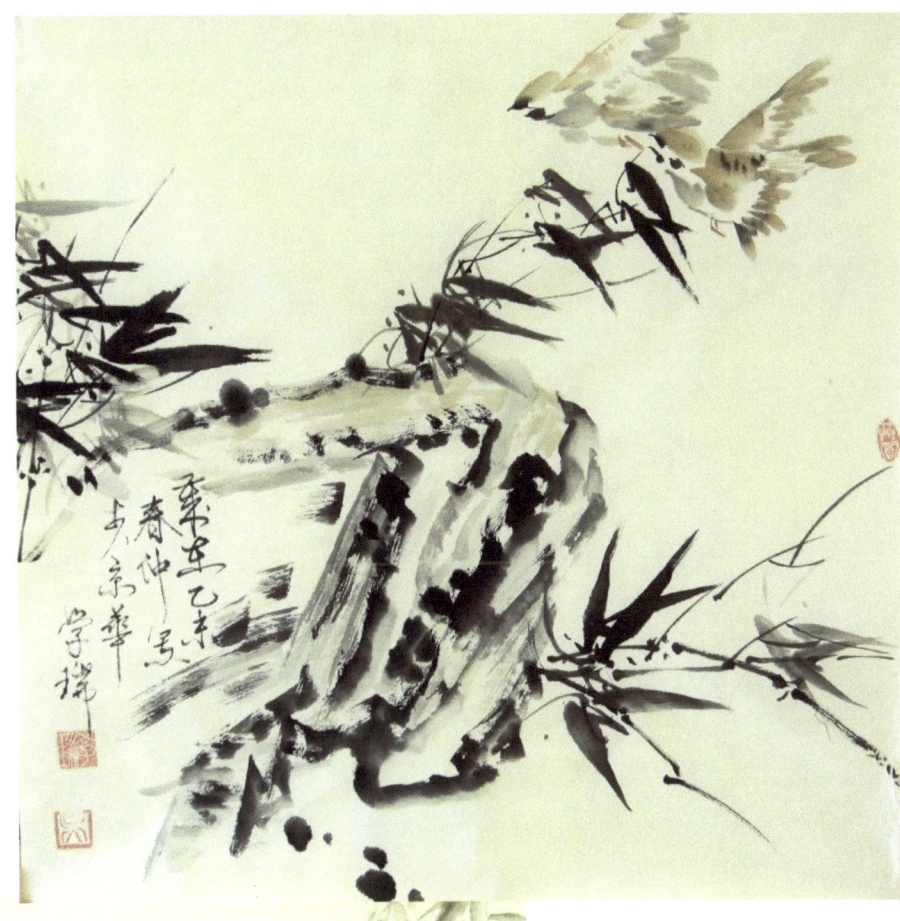

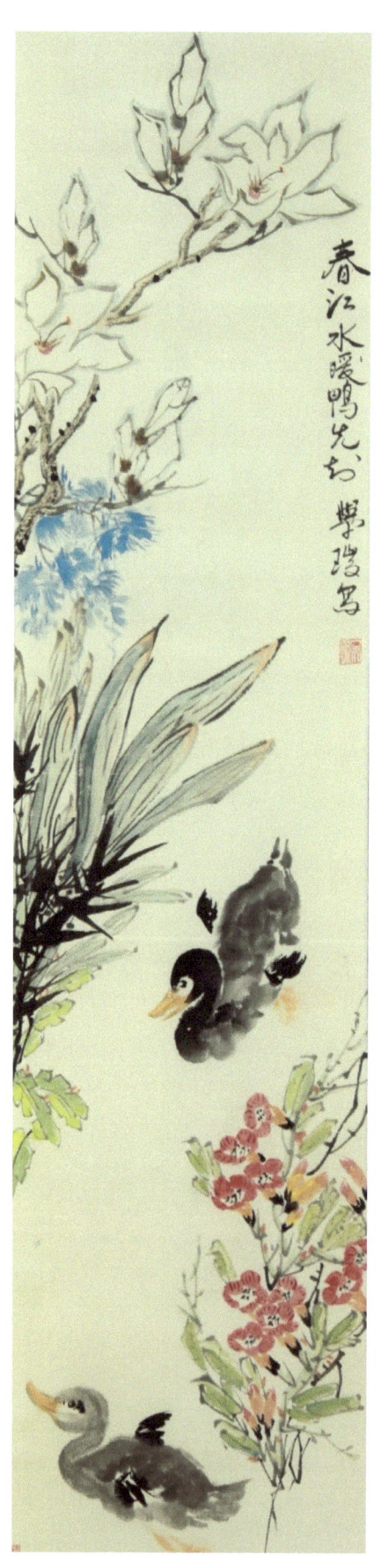
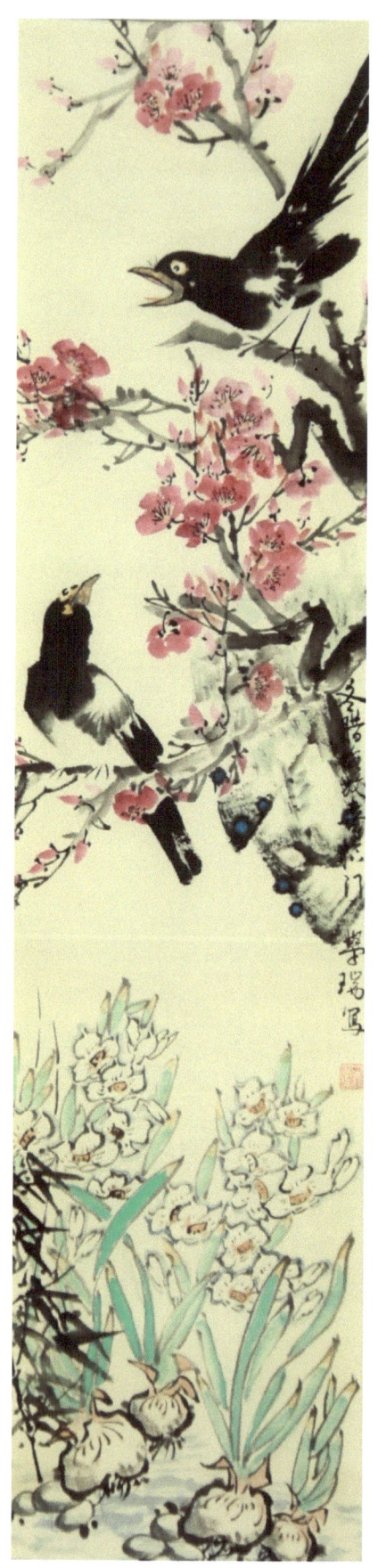

14

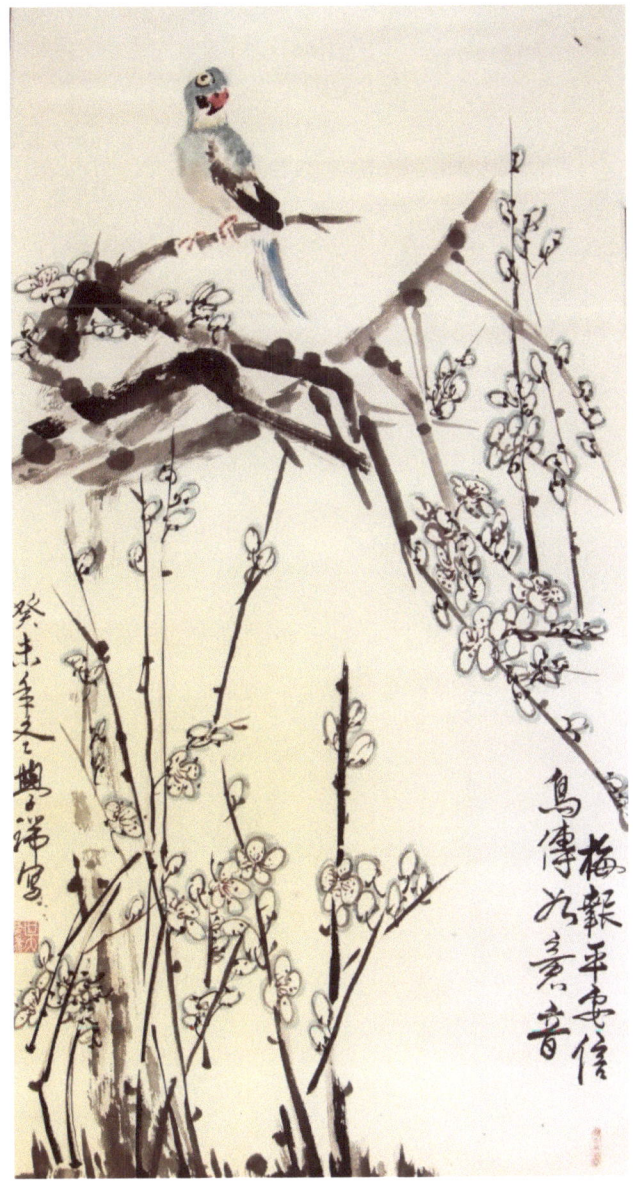
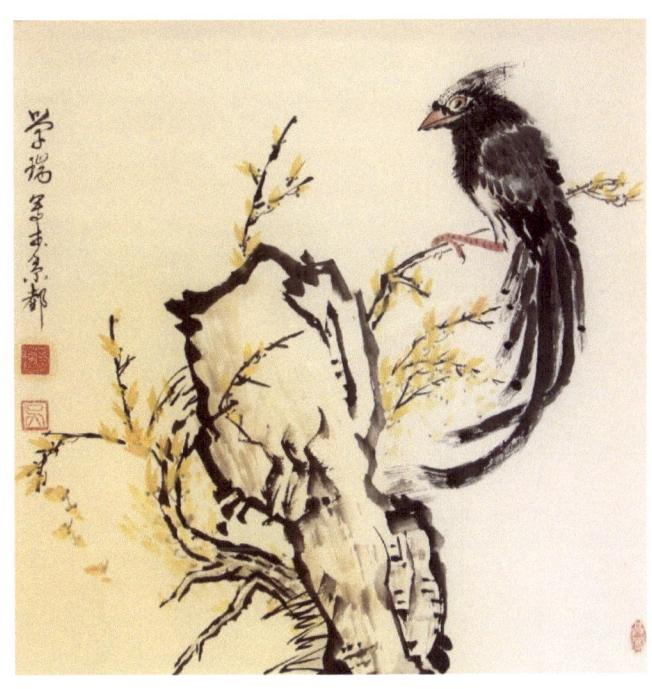
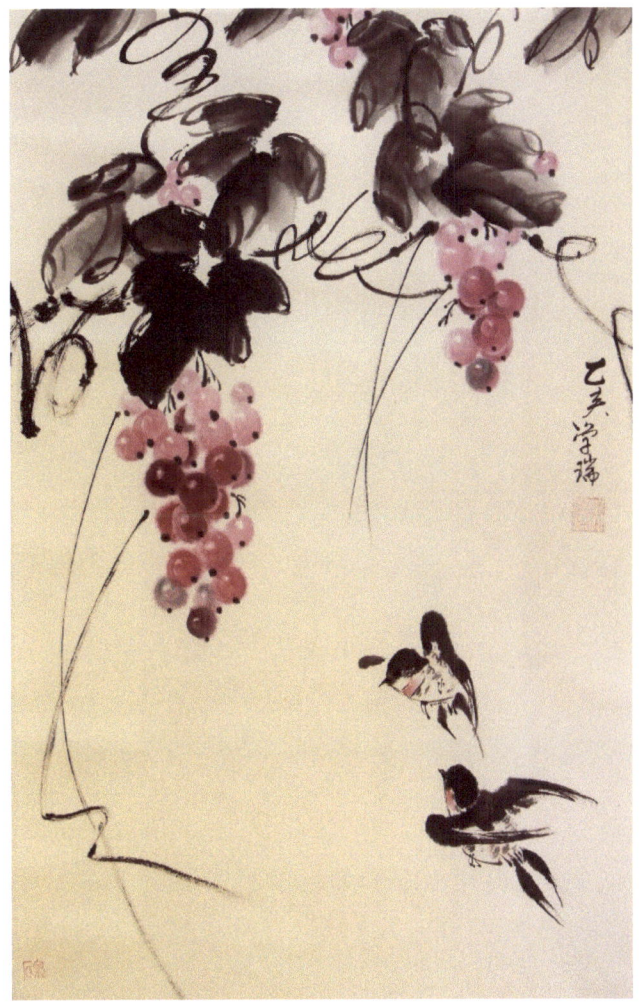

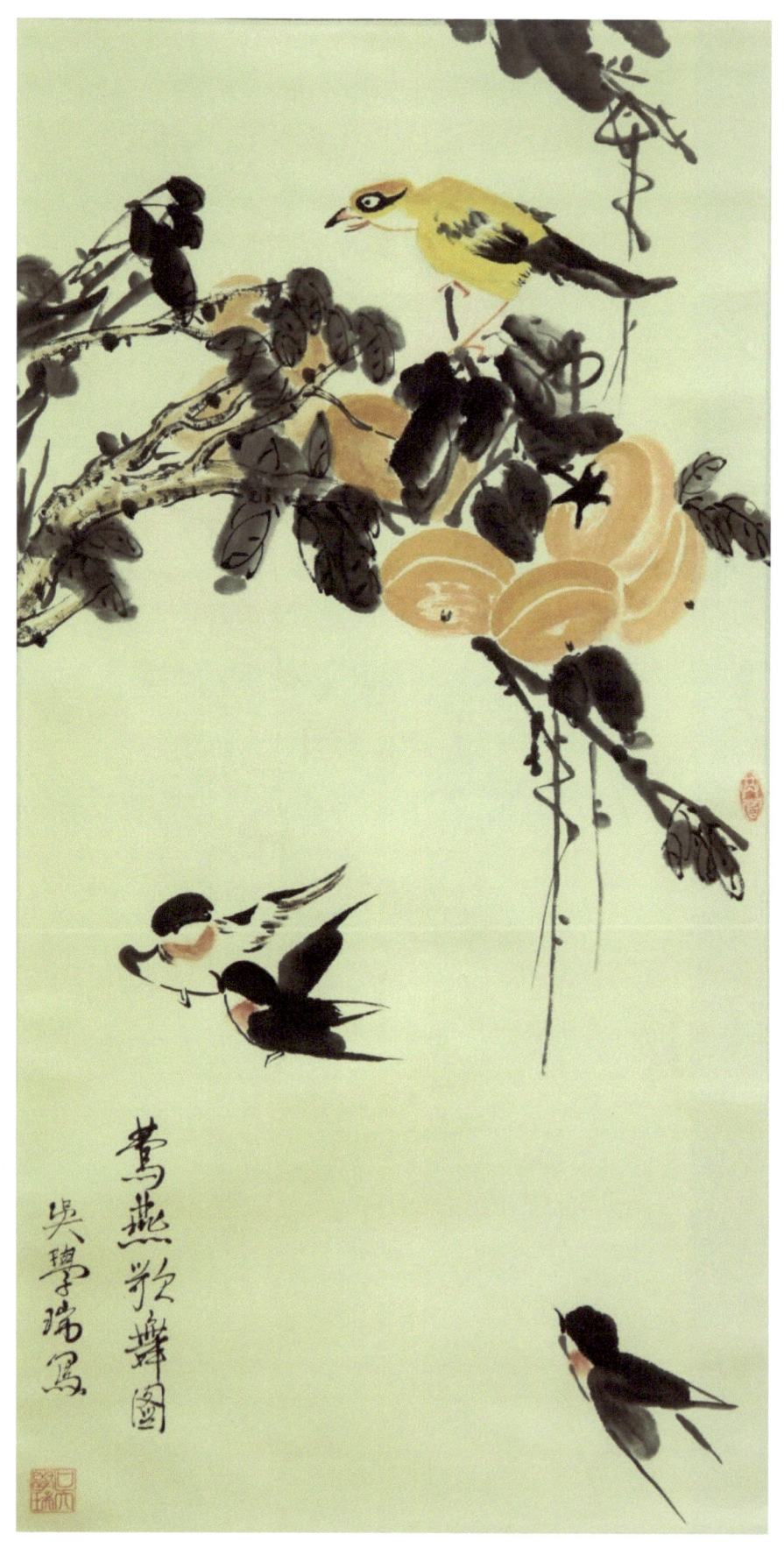

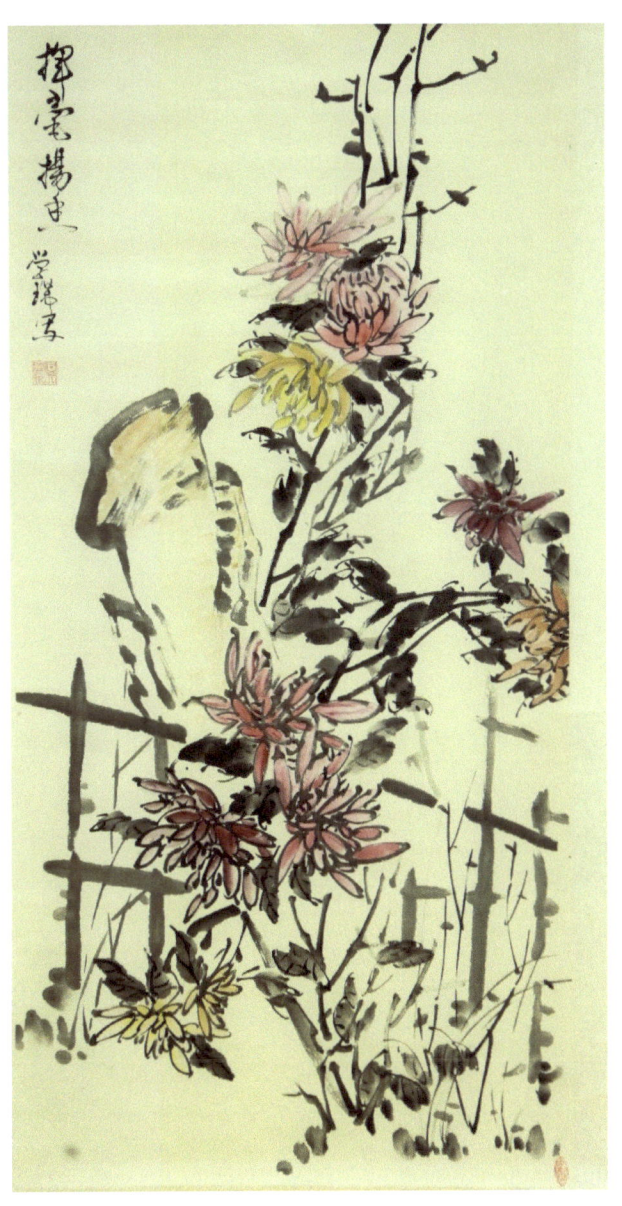
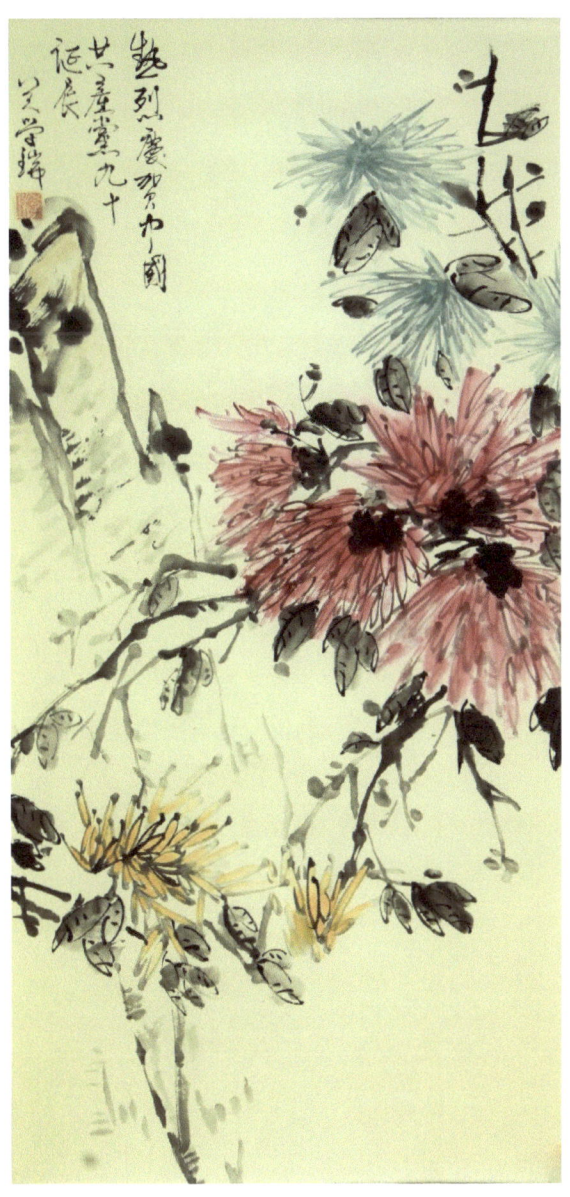

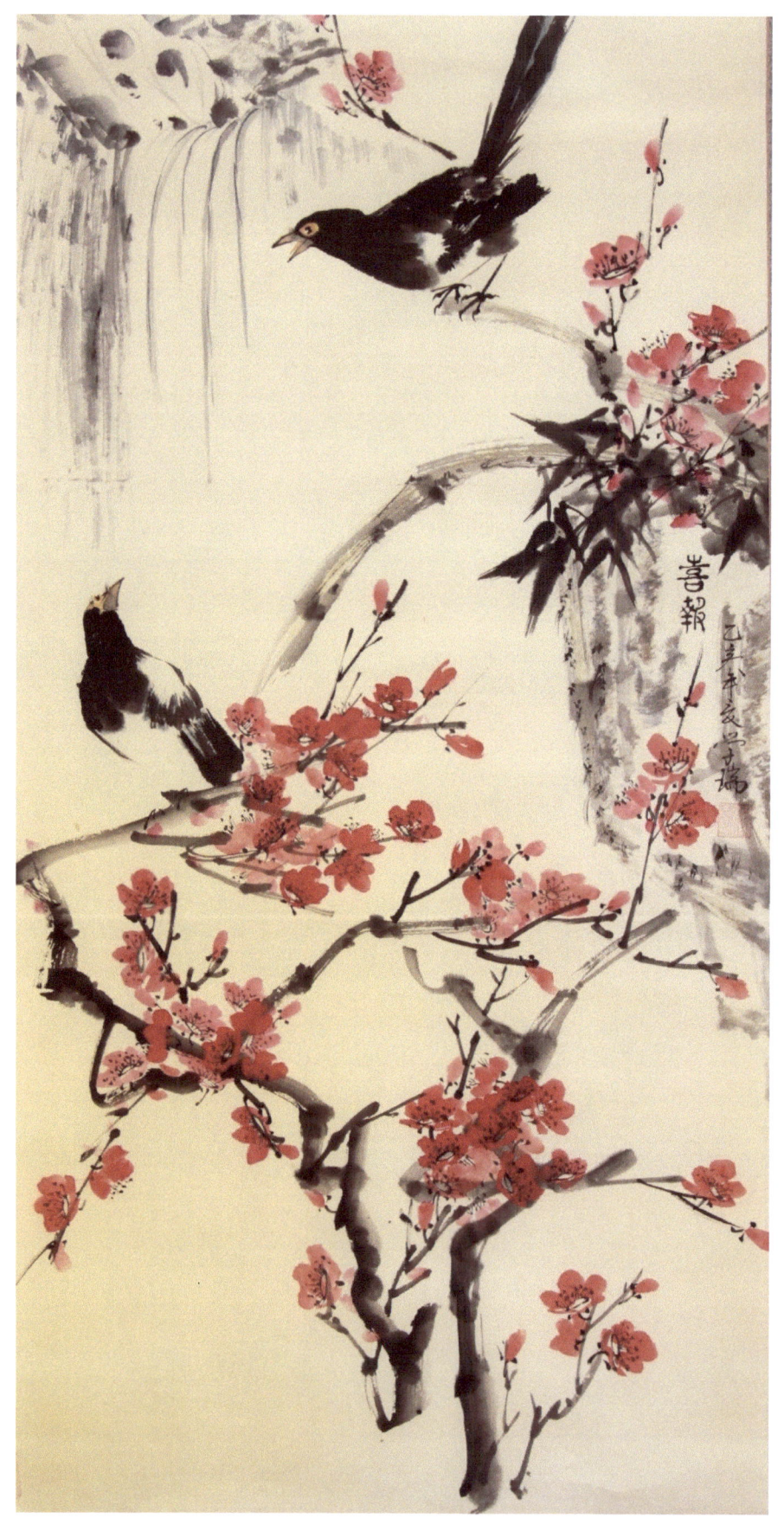

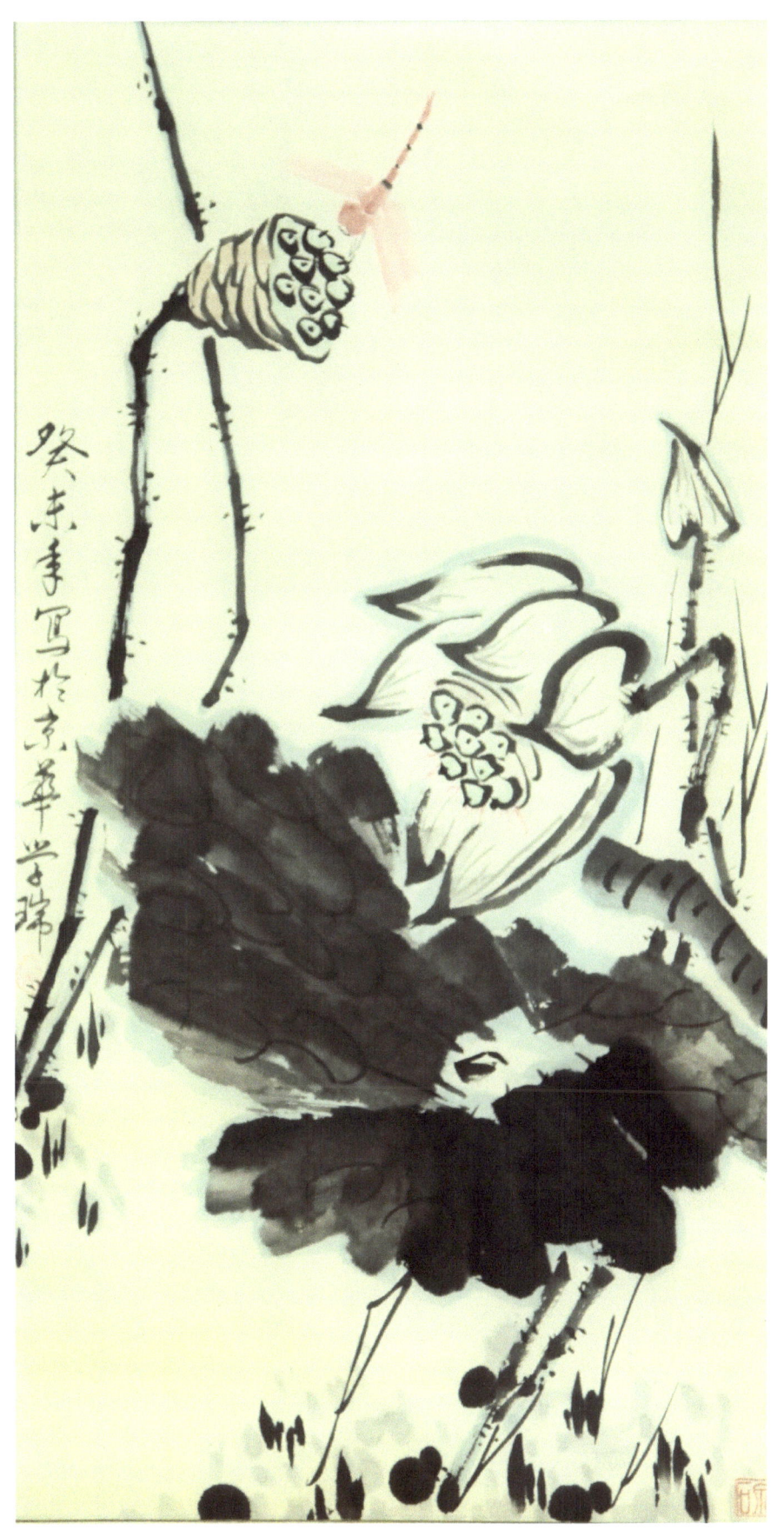

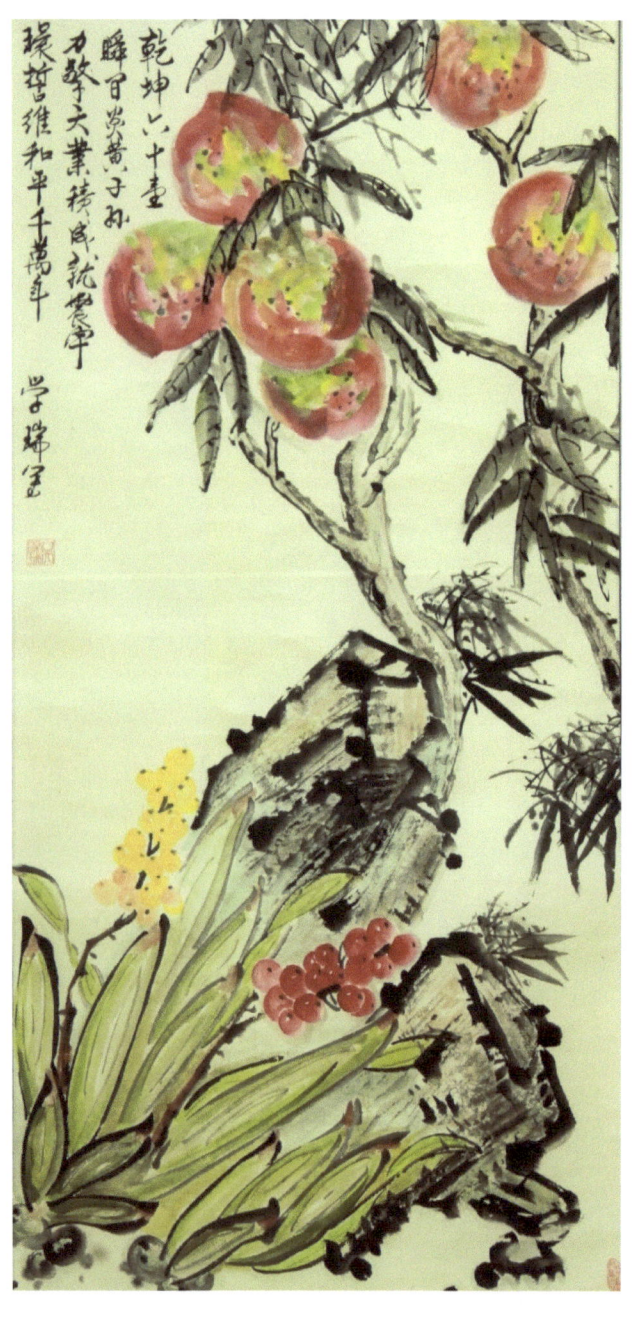
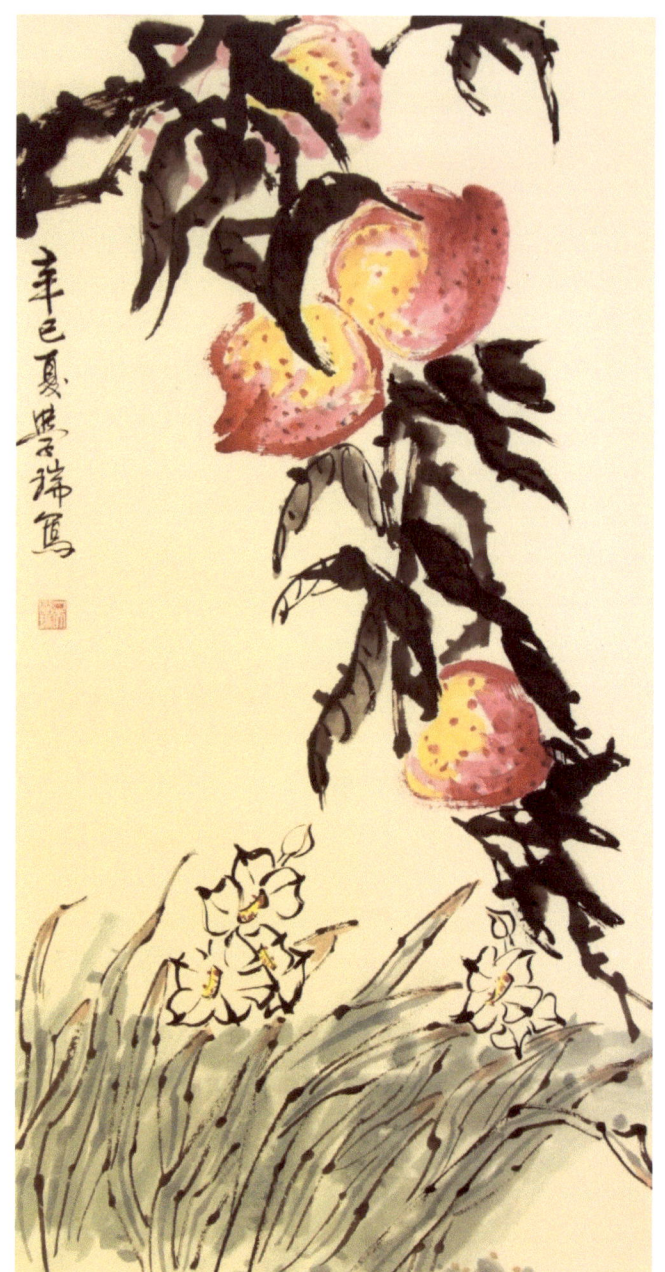

20

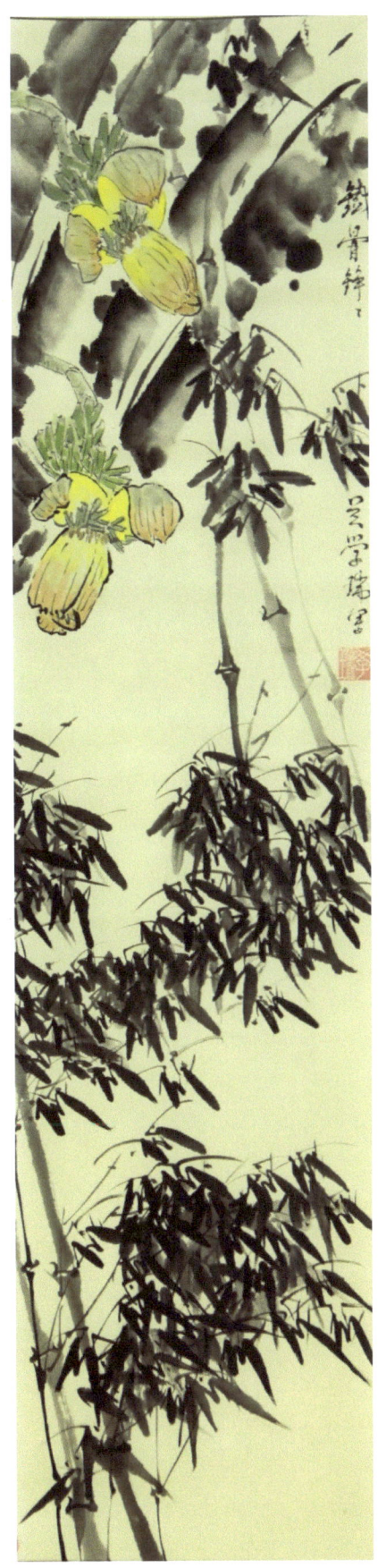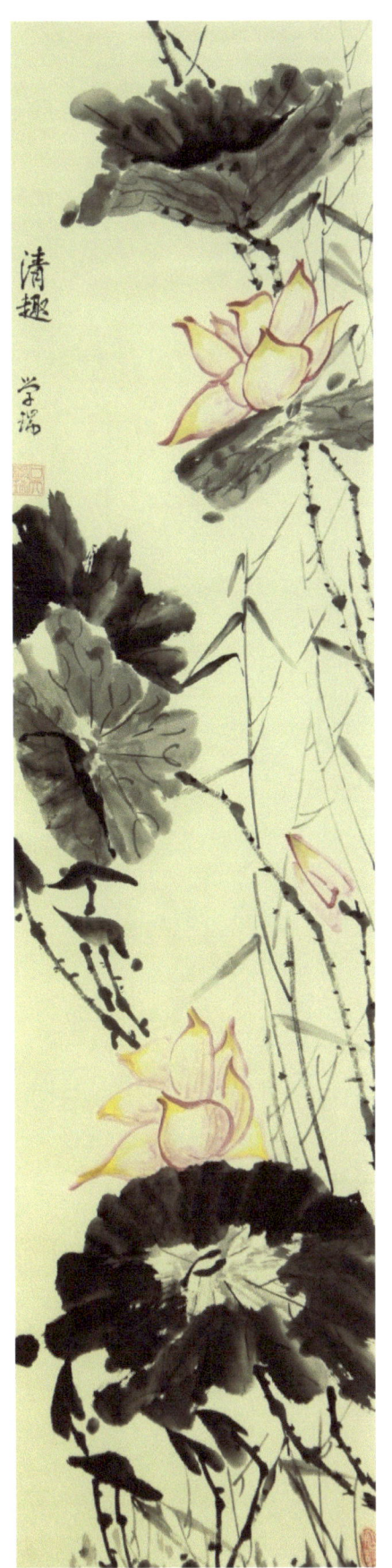

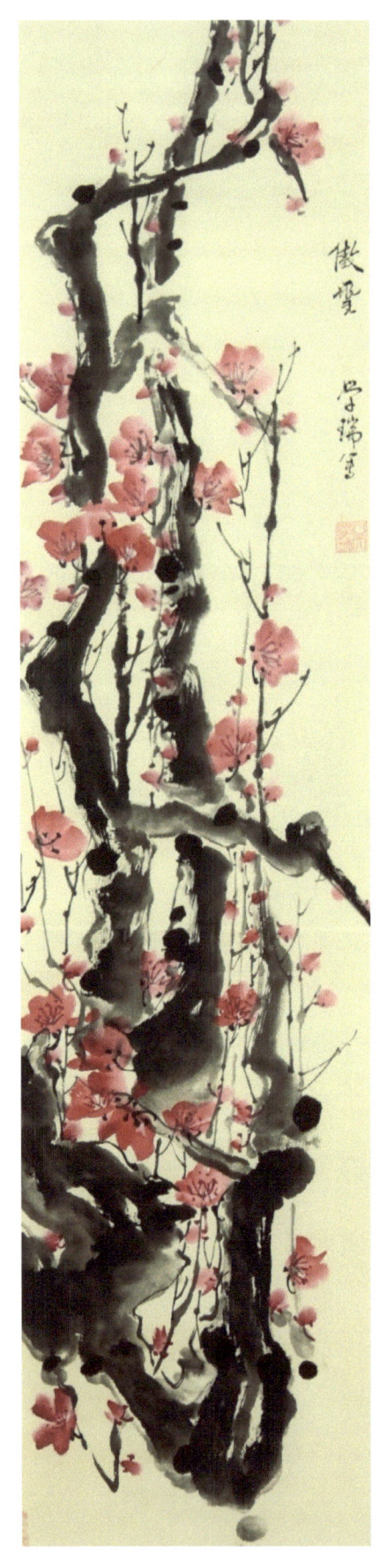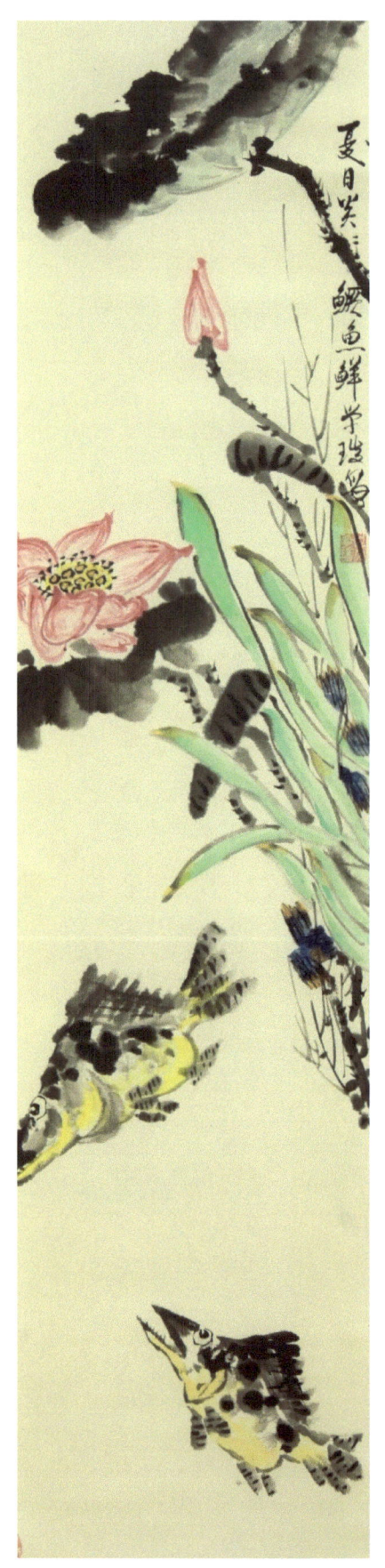

22

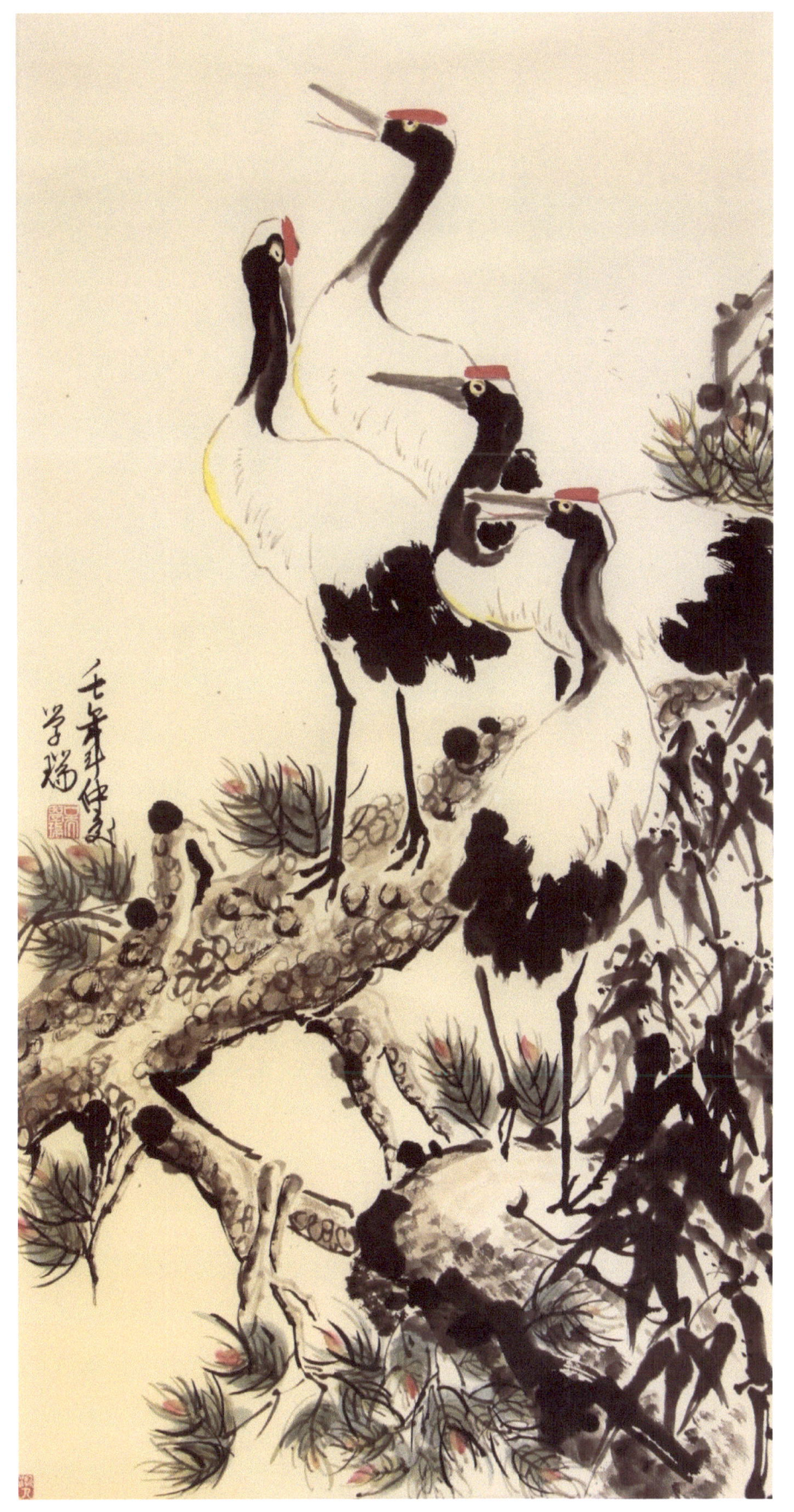

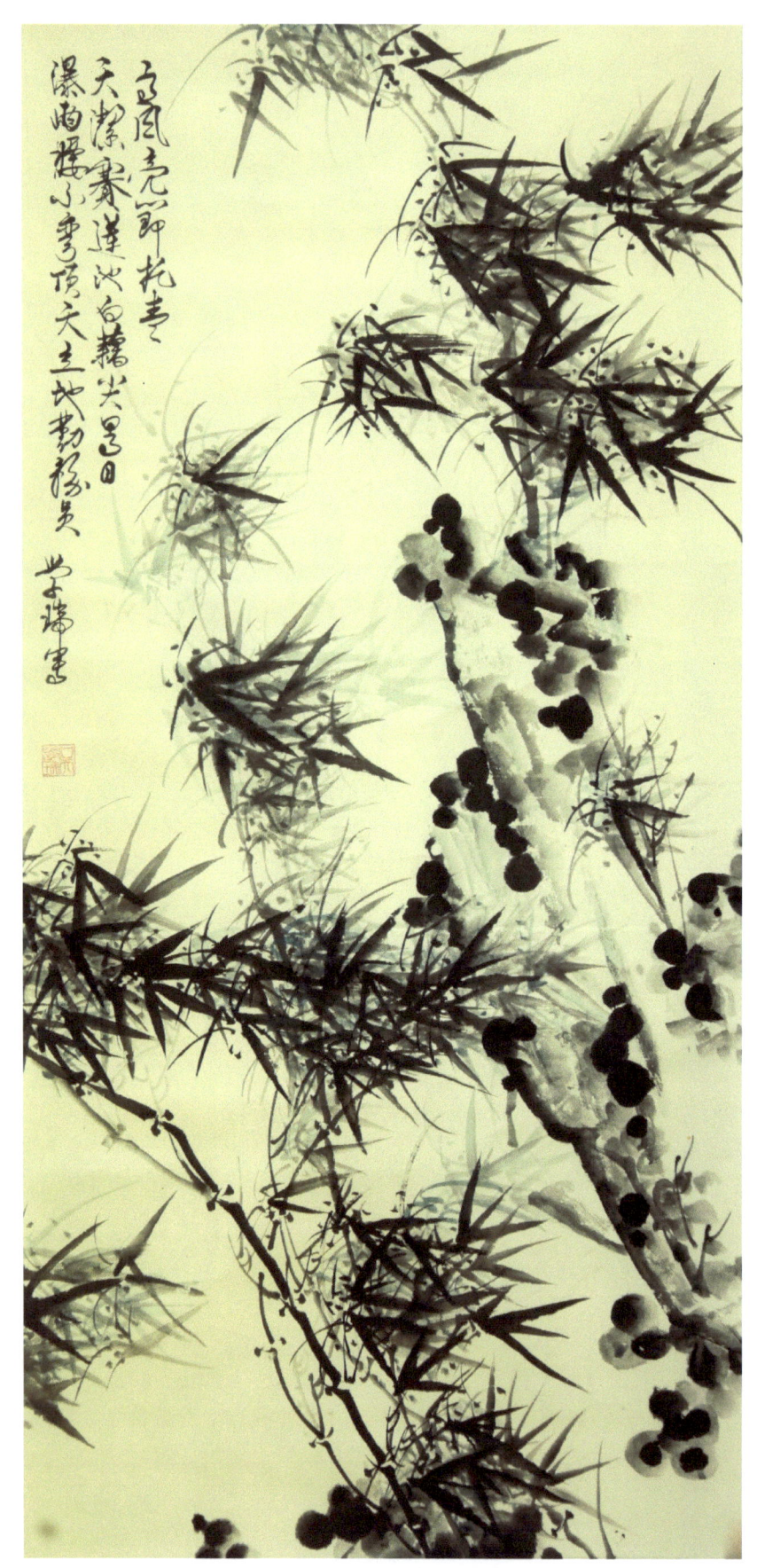

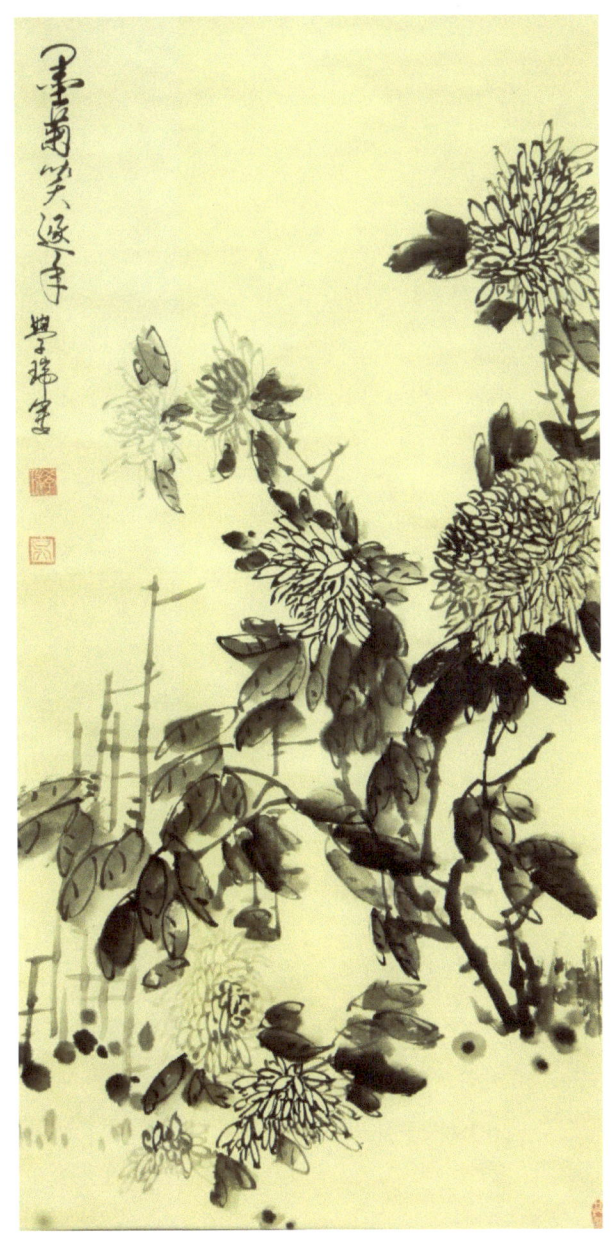
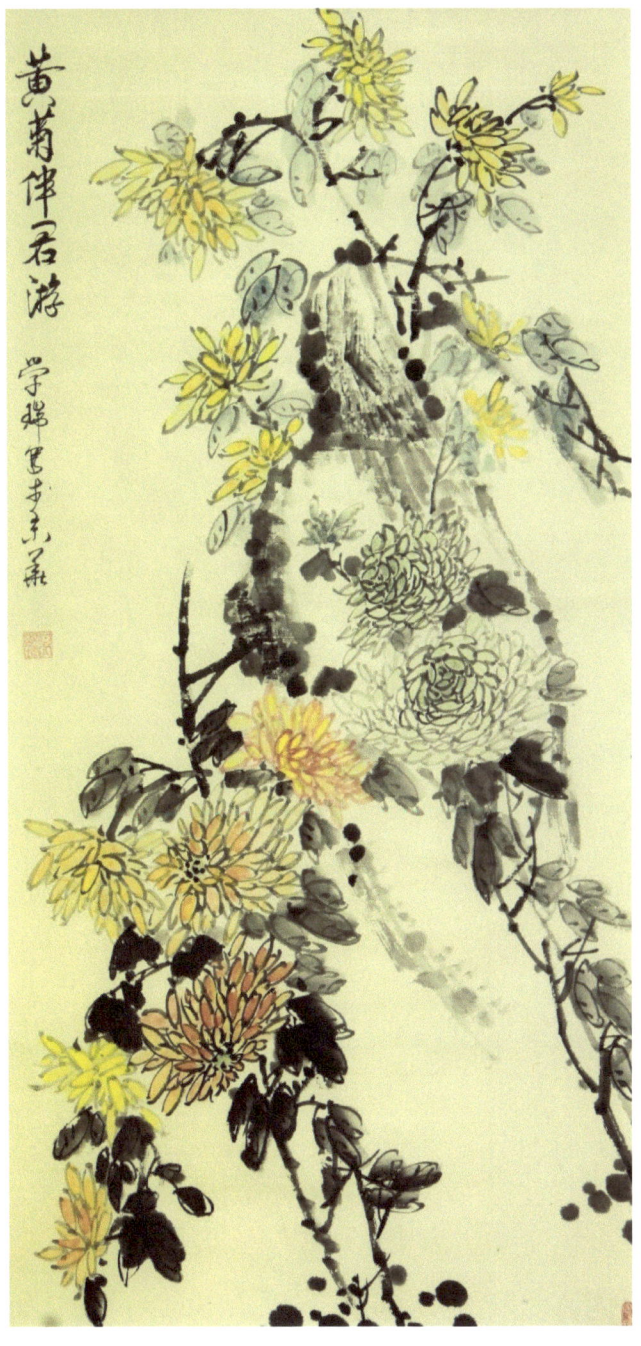

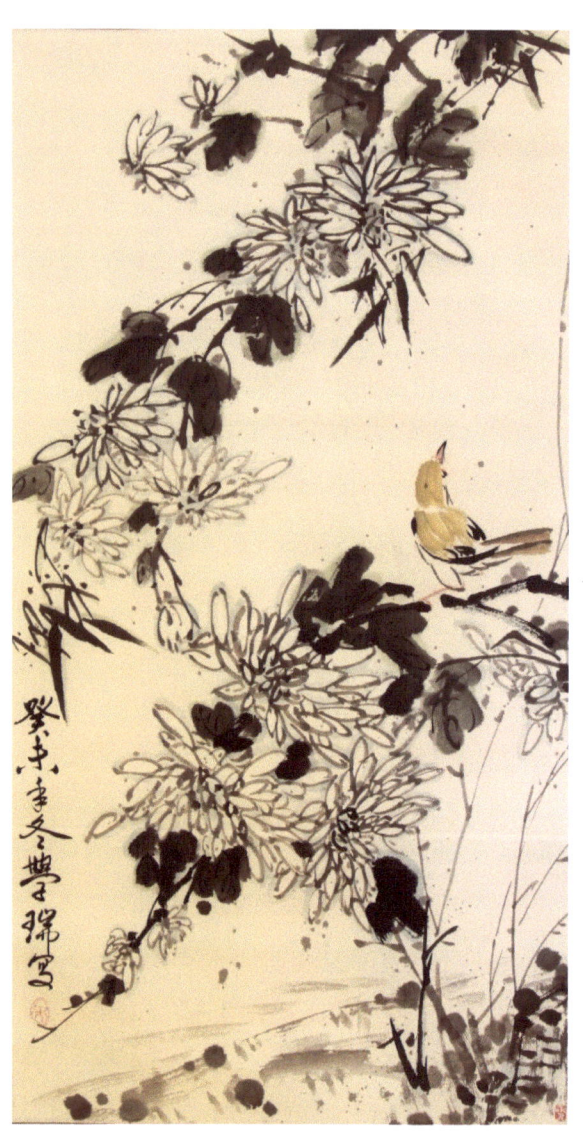
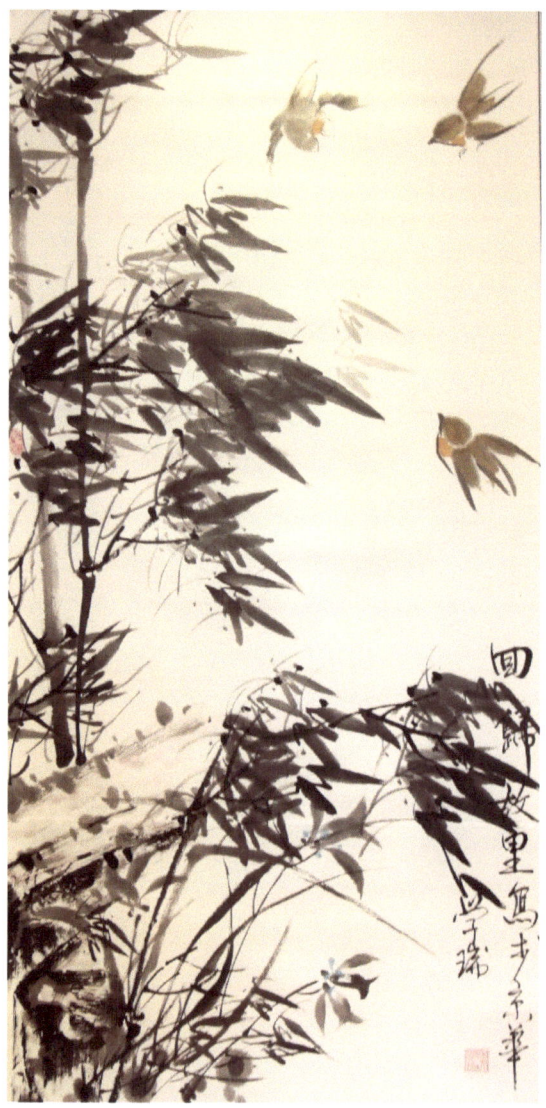

虎虎生威

---- *Tiger* ----

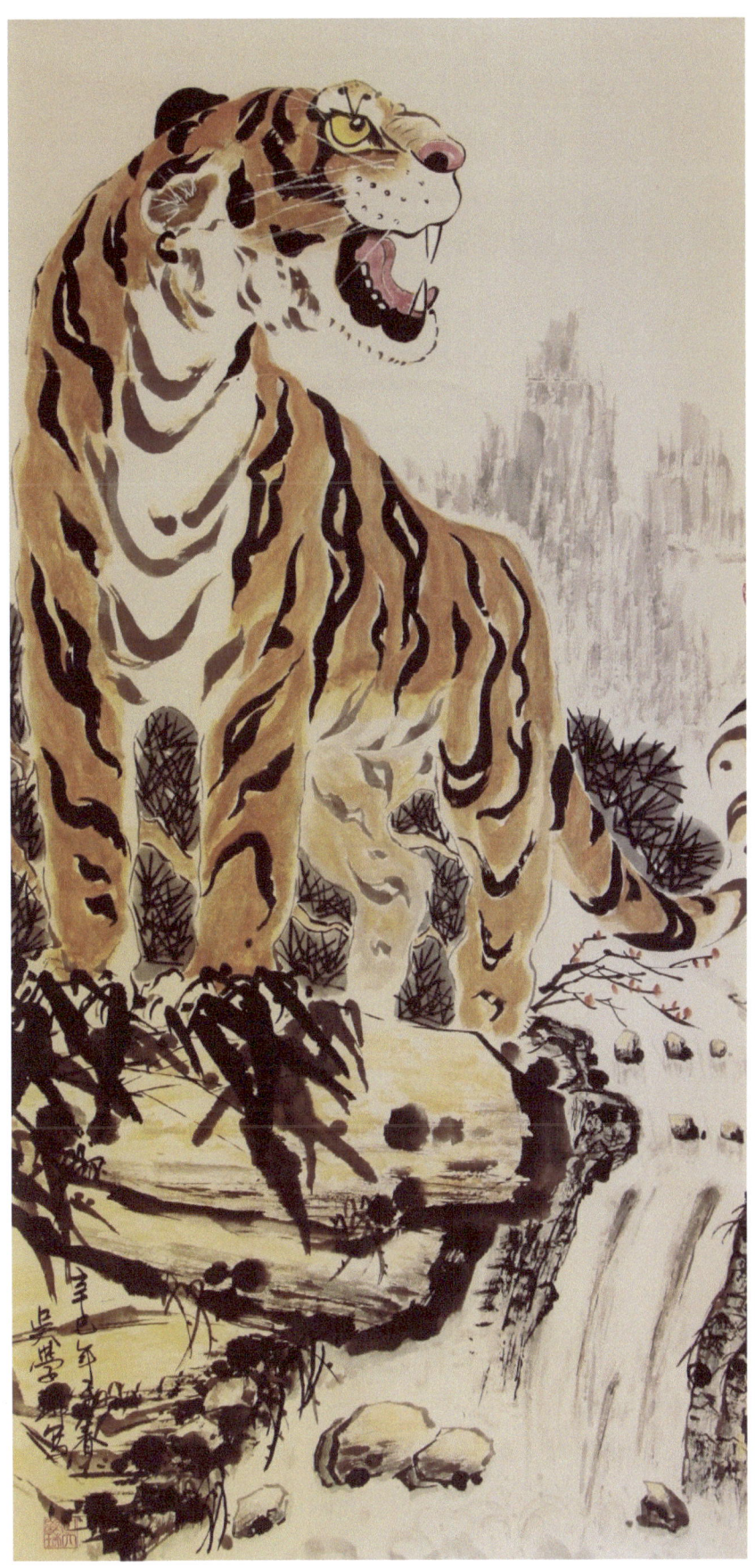

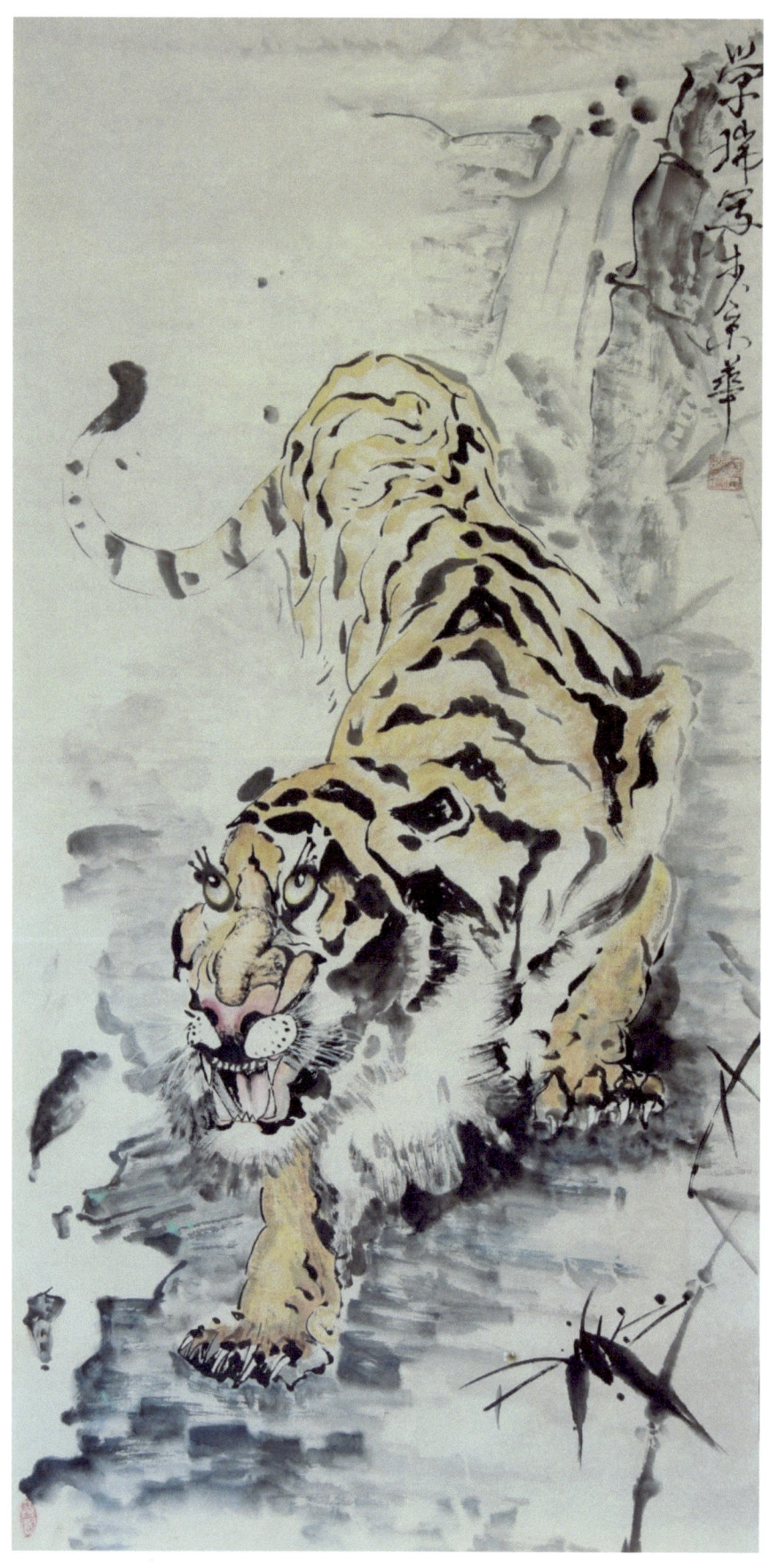

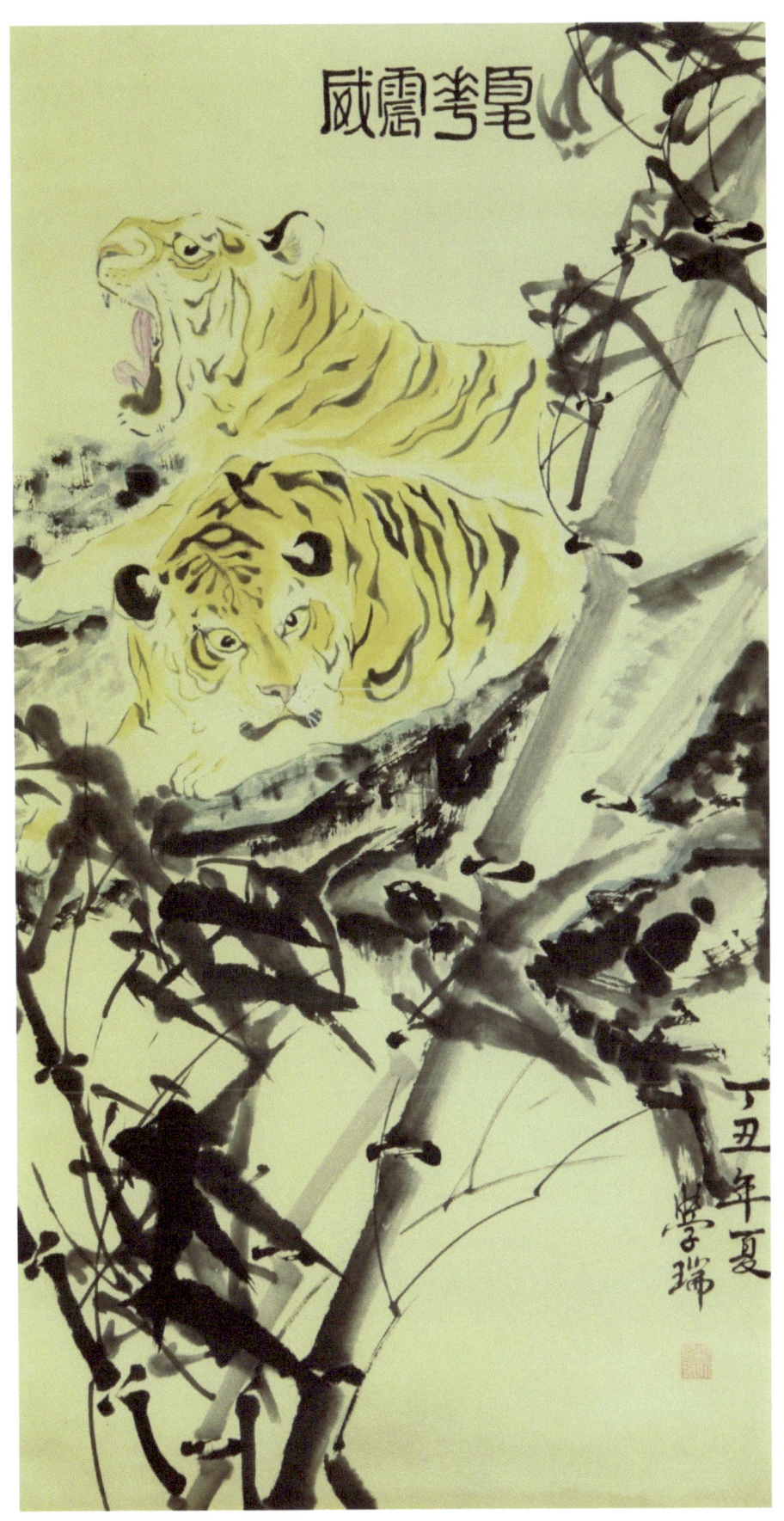

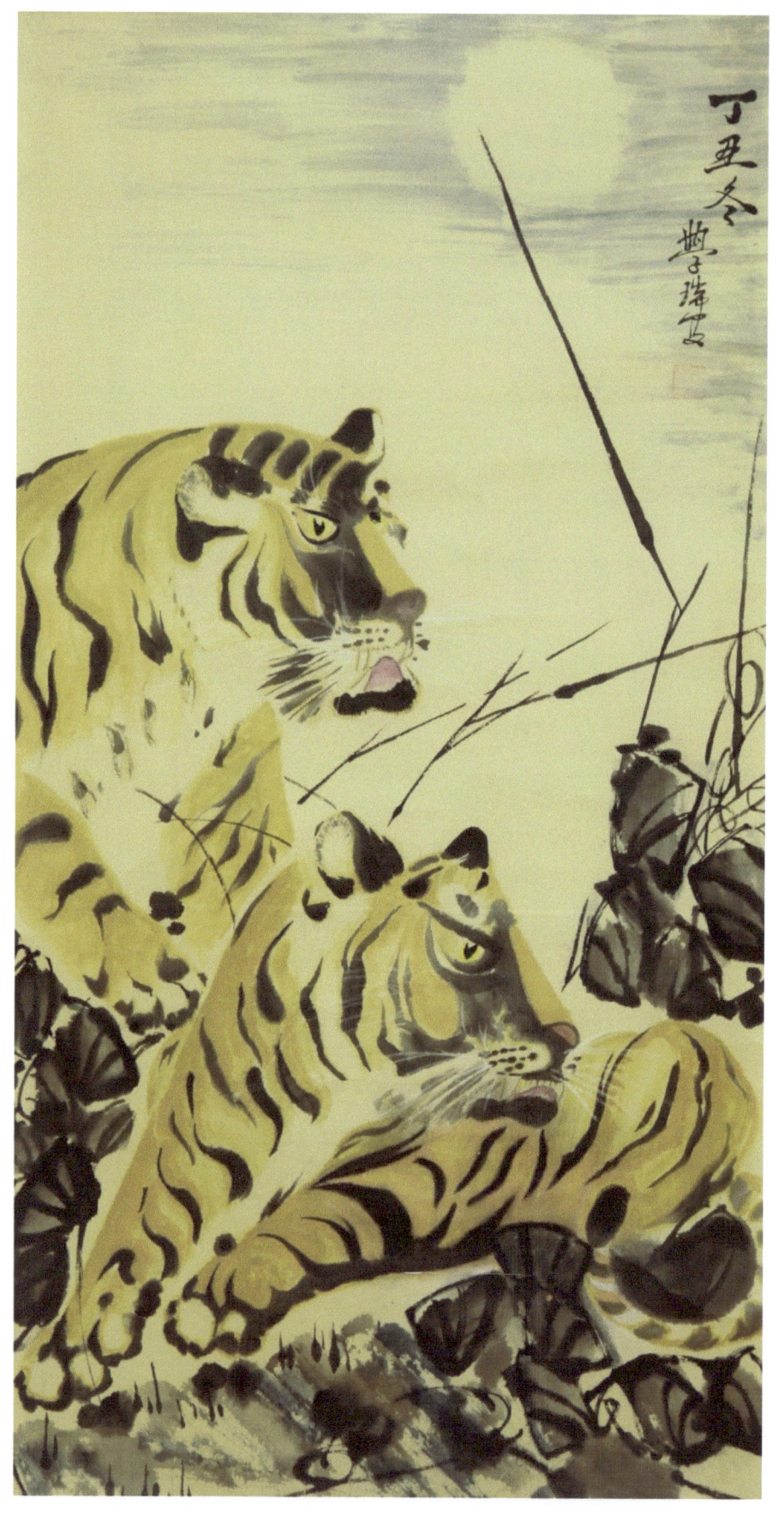

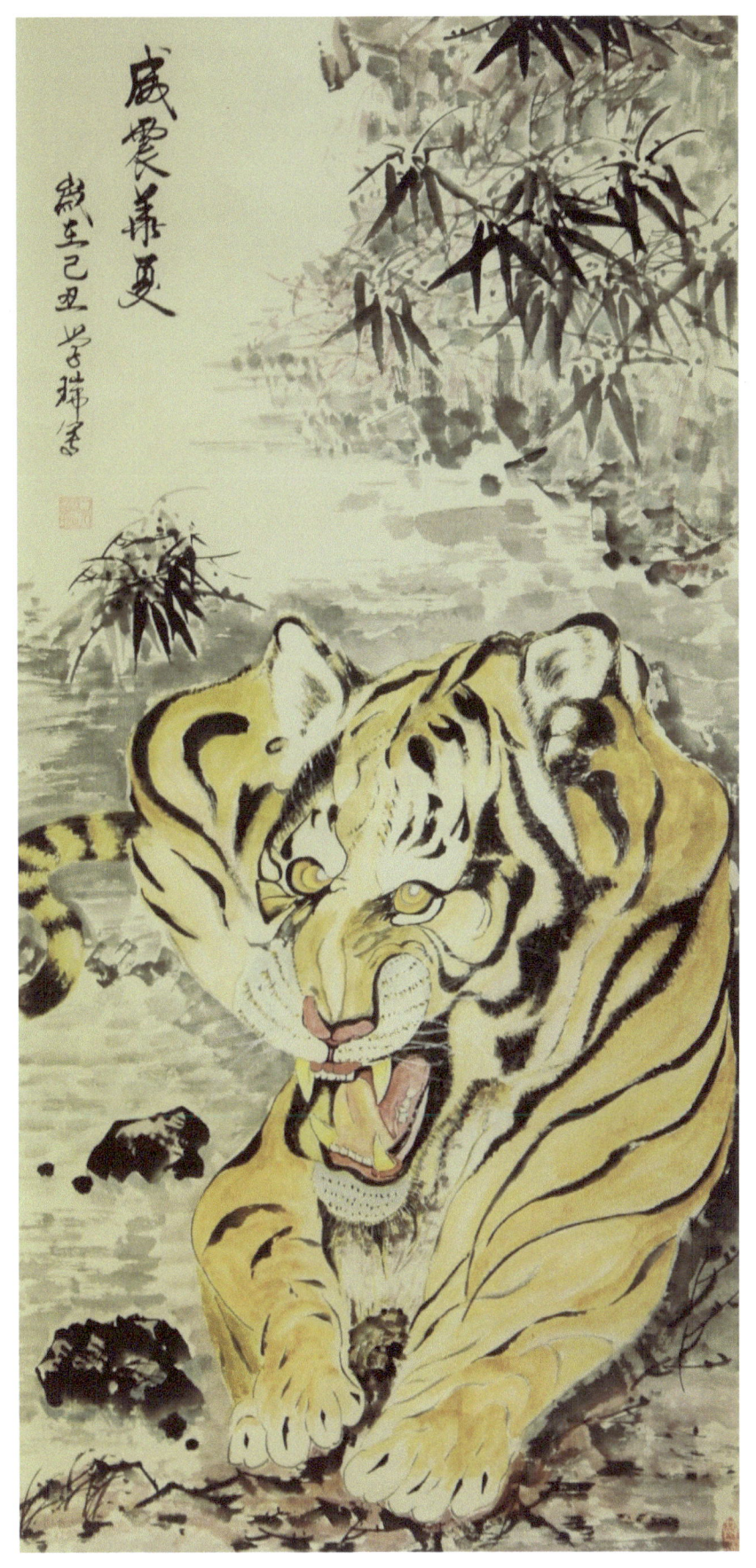

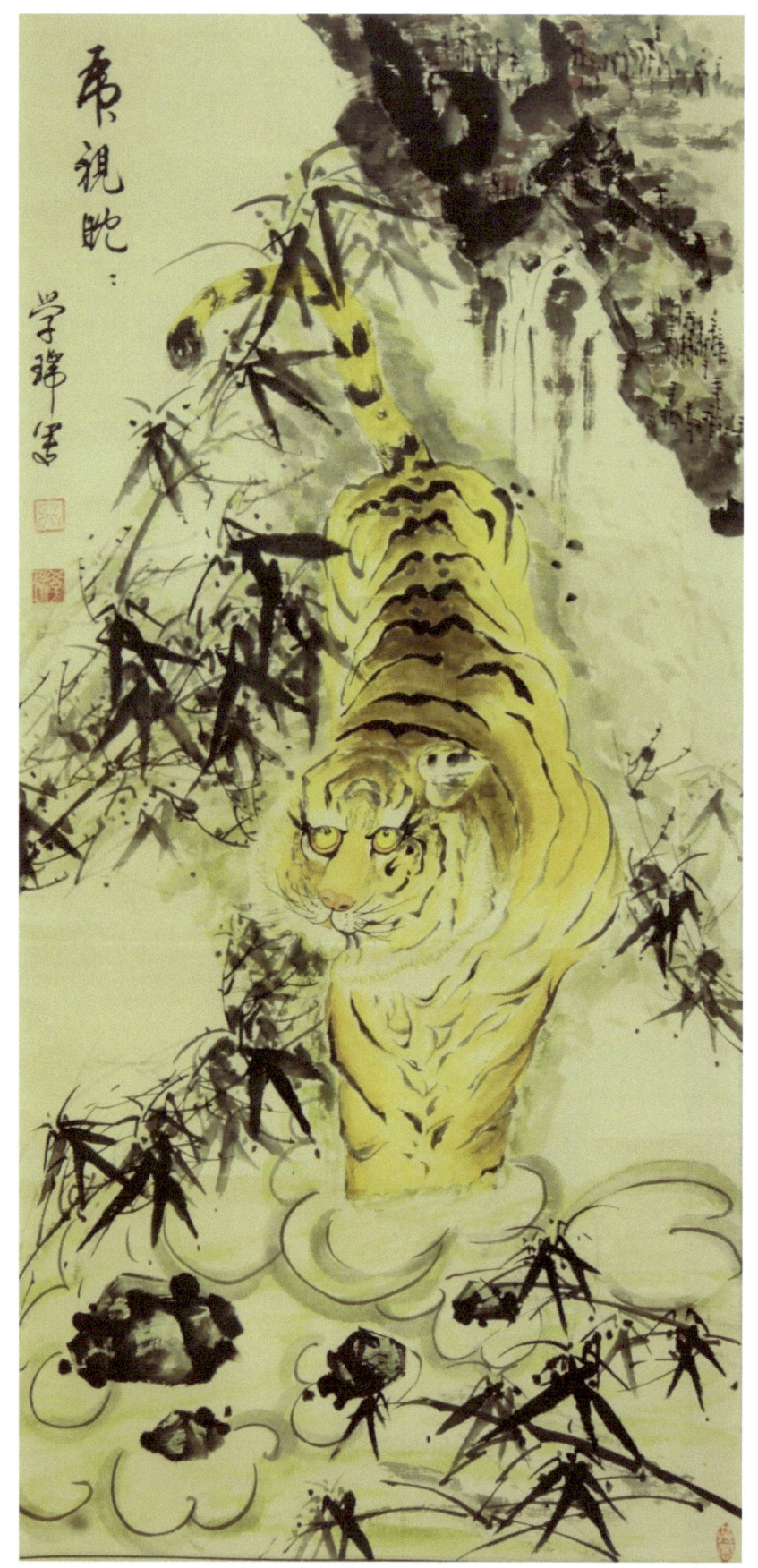

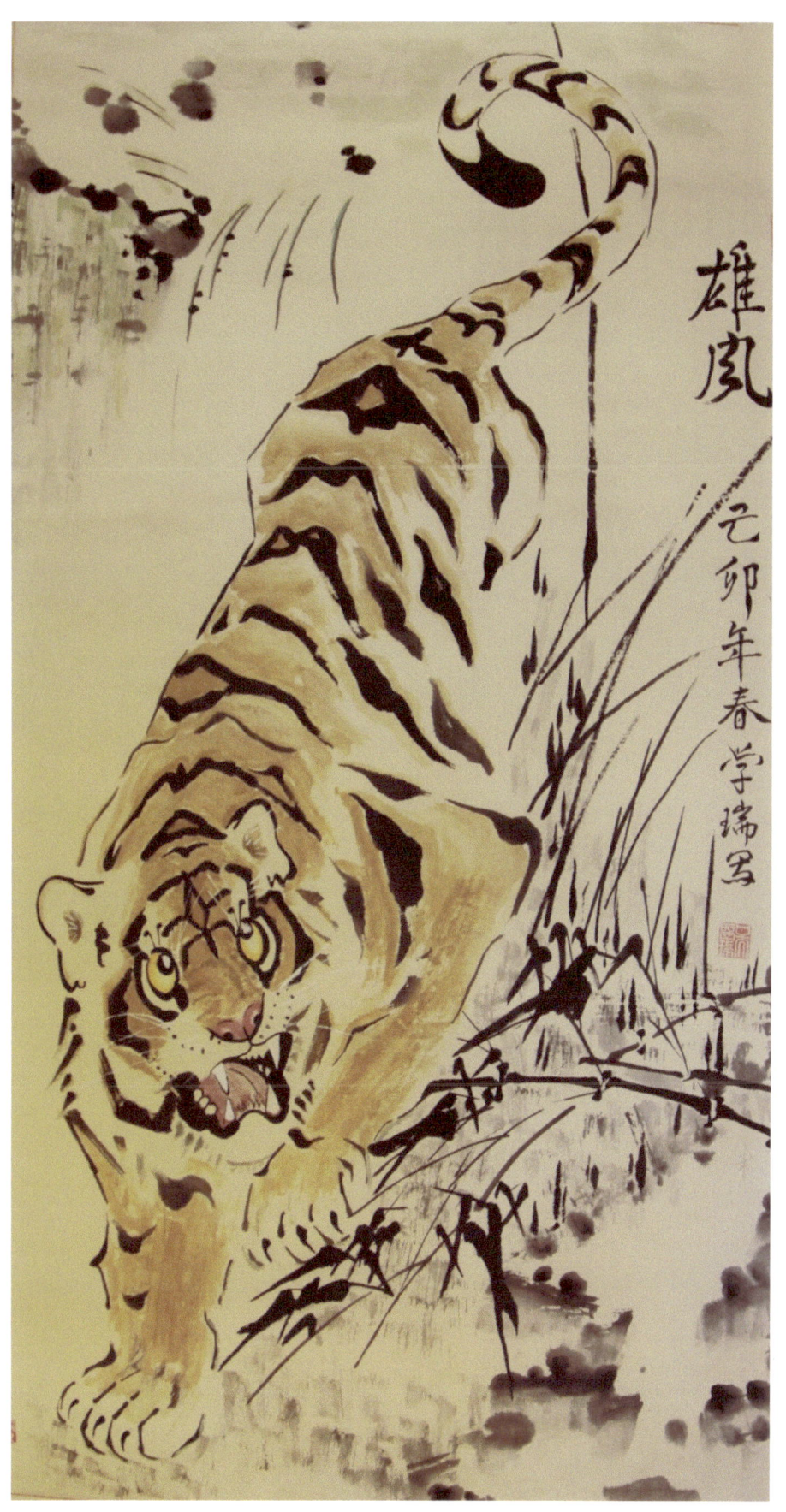

马

---------- Horse ----------

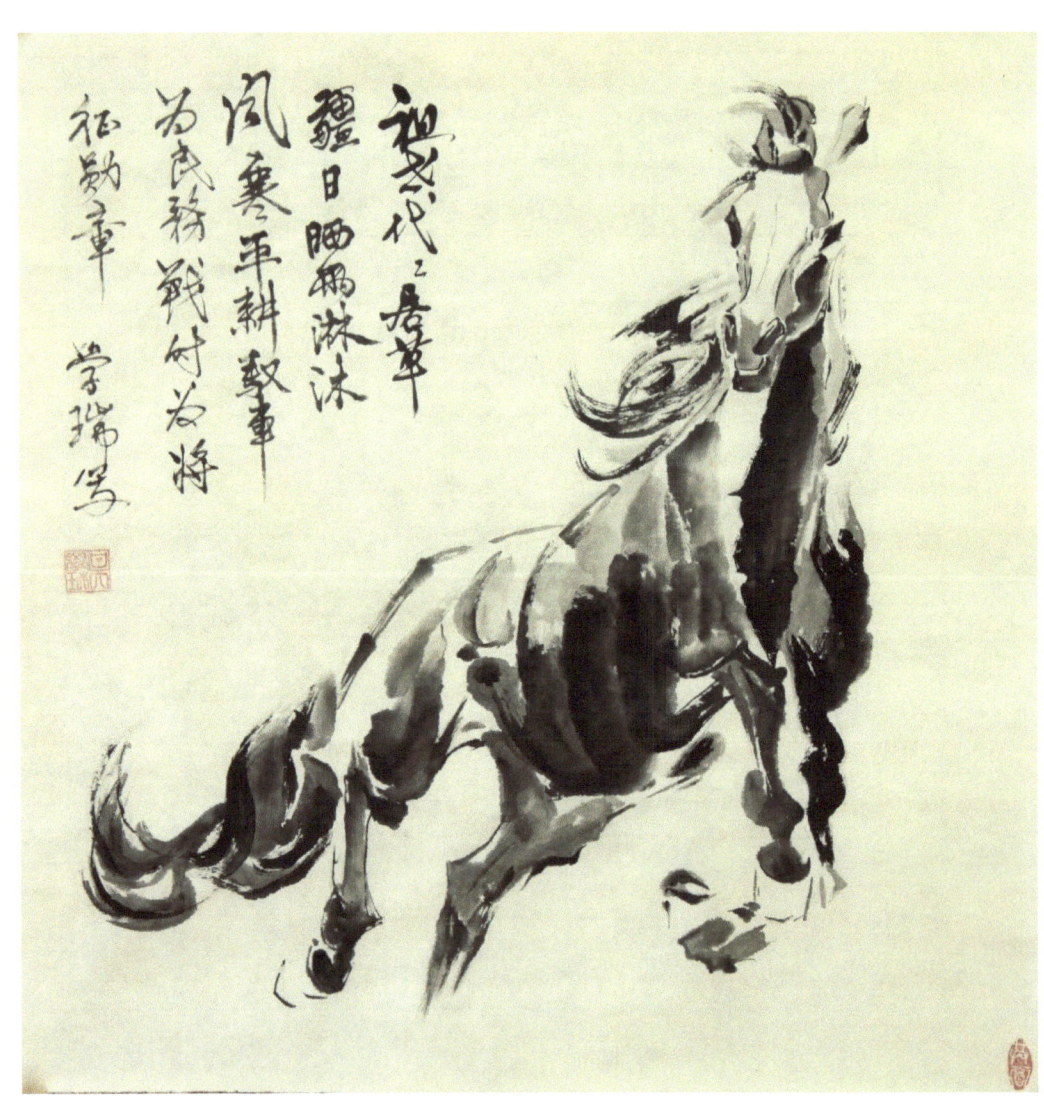

34

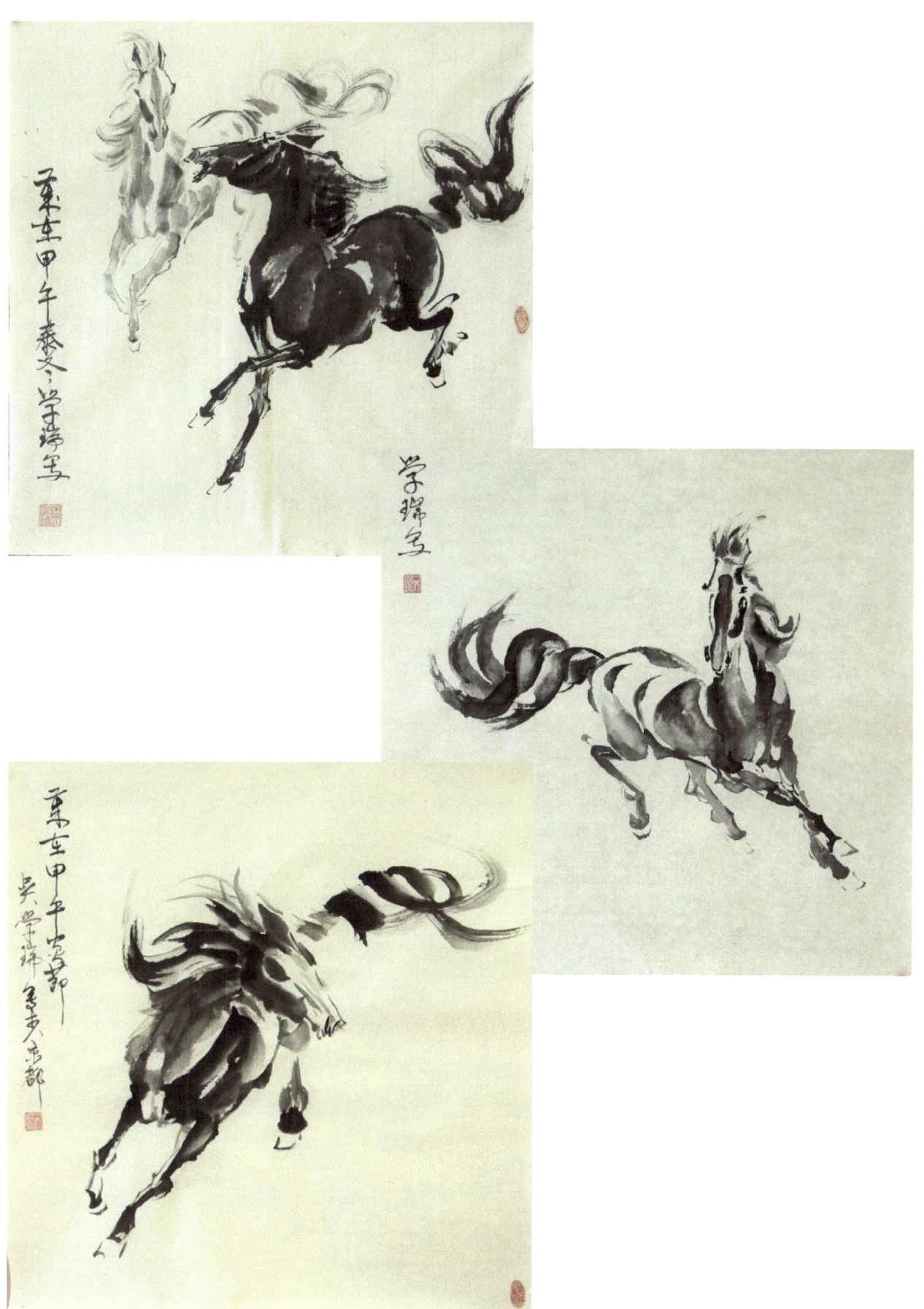

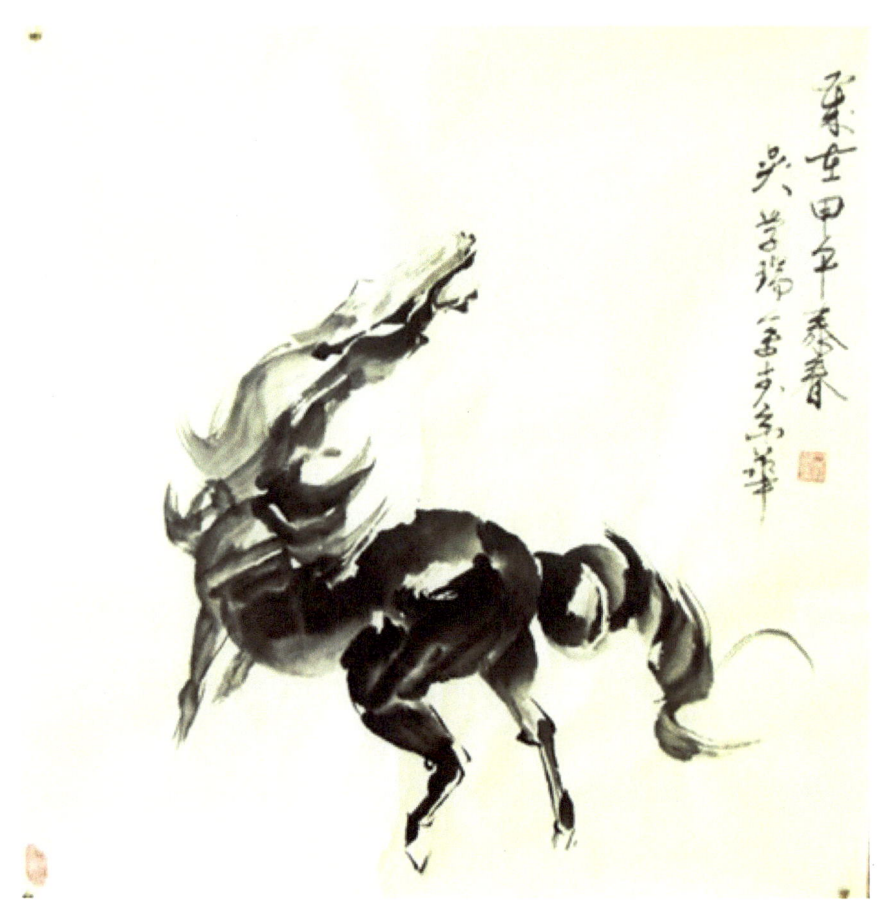

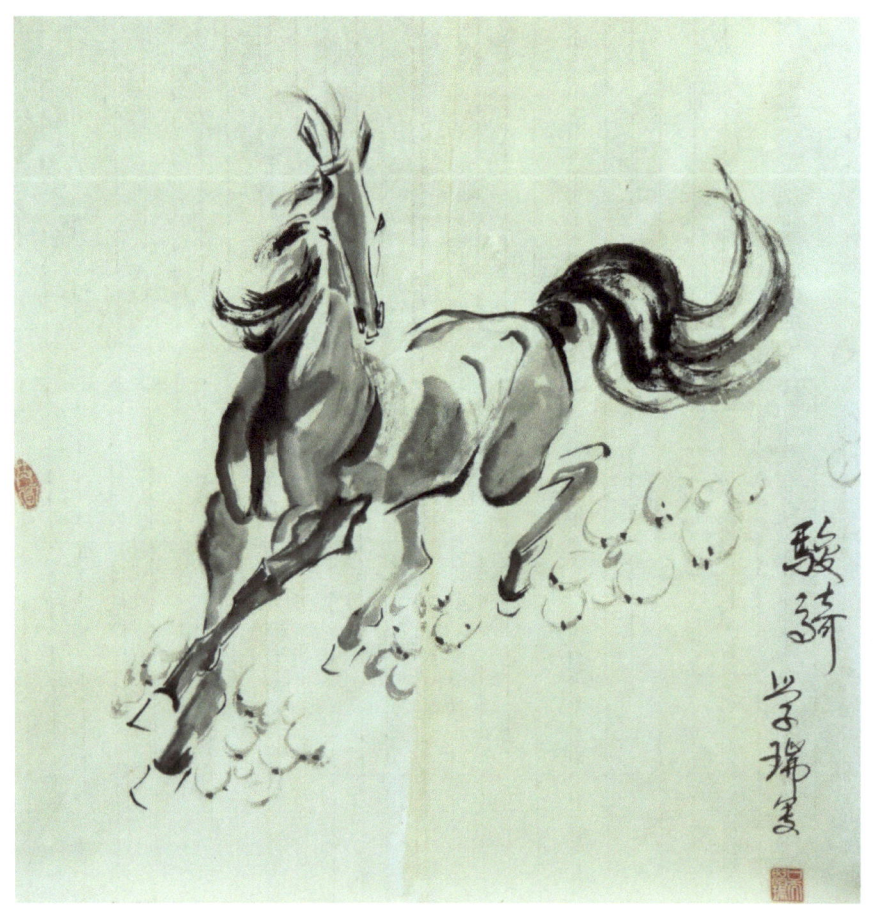

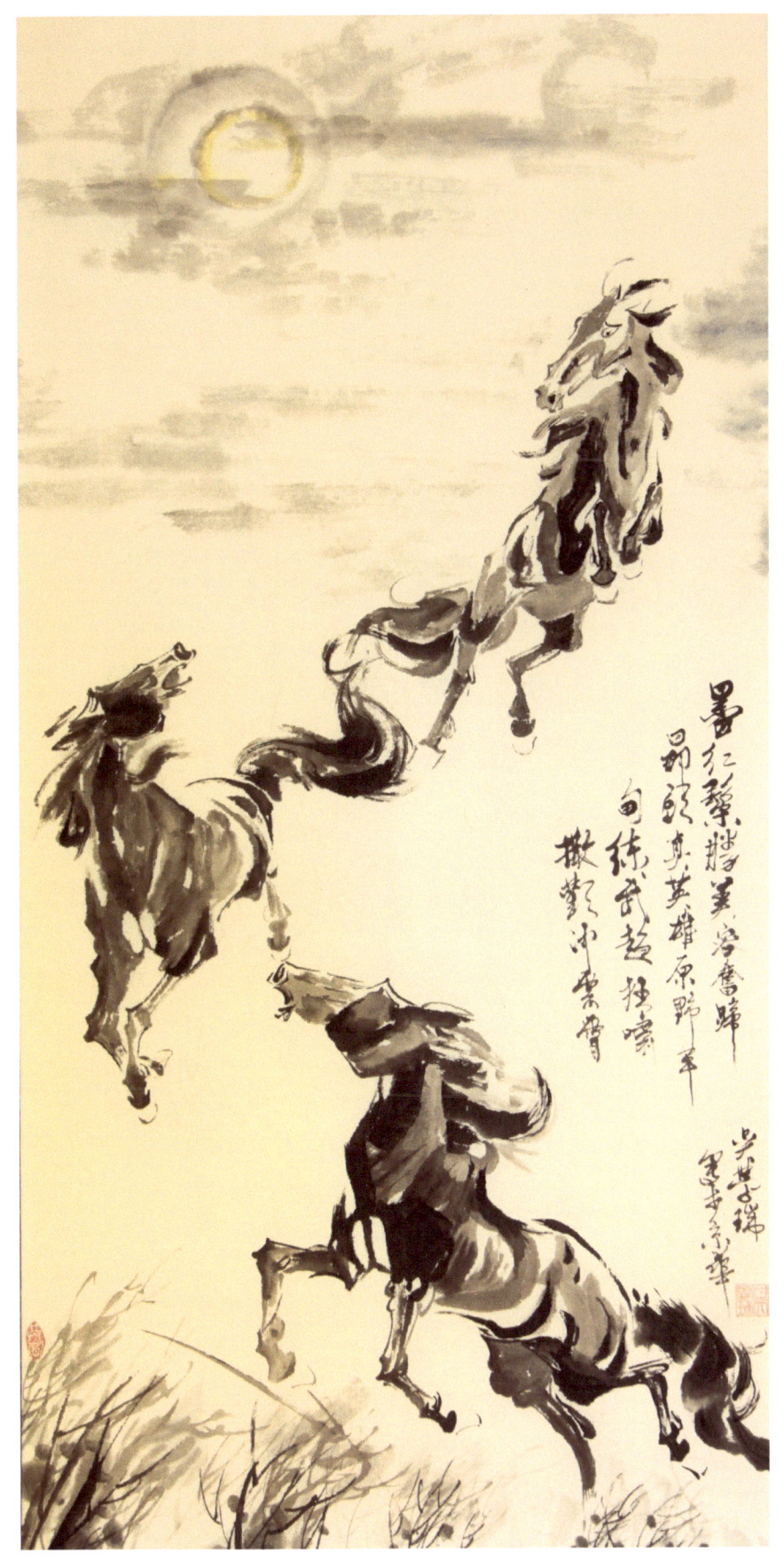

山河壮水 ----- Mountain and valley -----

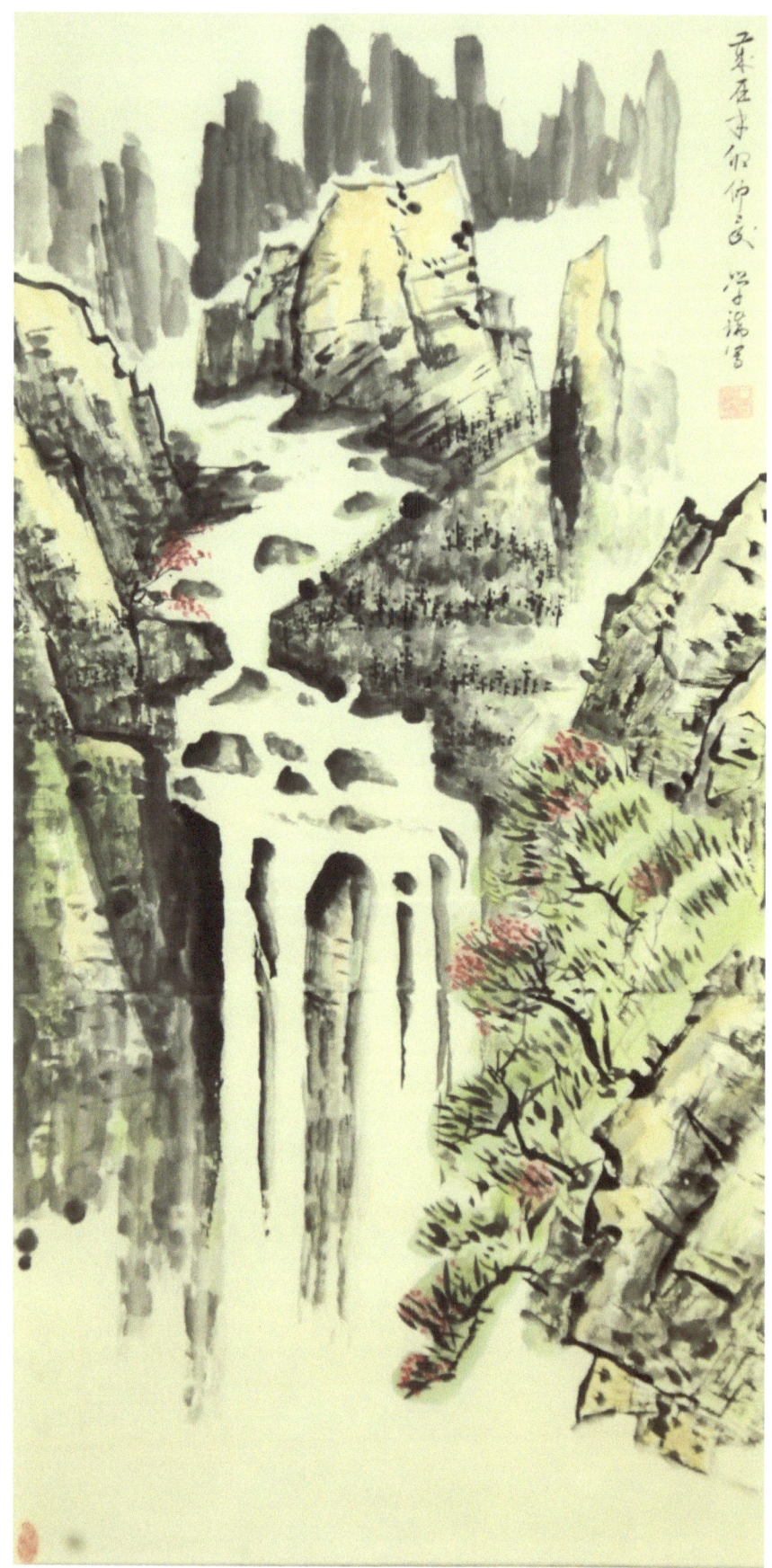

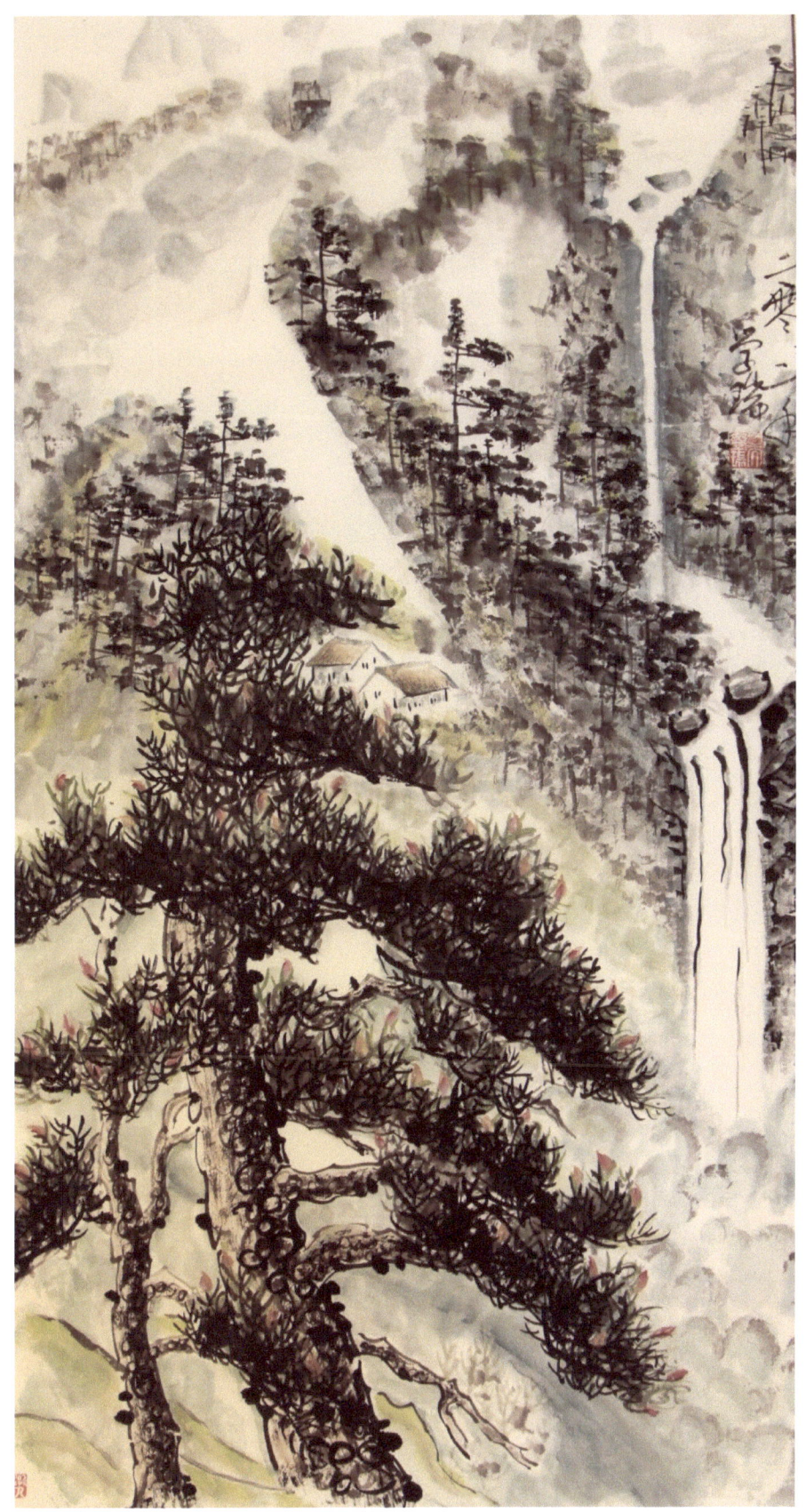

编后语

 此书的全部书画出自我的姥爷之手。我敬仰的姥爷，孜孜不休，勤奋好学，默默无声的努力工作六十余年，一直是我学习的楷模。姥爷倔强刚毅的个性，成就了他对书画精益求精的执着追求。

 我从未接触过平面媒体的编辑工作。而这次在美国出版姥爷的这本书画集，从整理、搜集作品画稿及相关照片，到撰定色彩基调、排版、编辑、校对等等，工作量繁杂浩大，压力虽十分沈重，但我仍决定独力、尽力来完成。过程中，得到了不少亲朋好友的帮助，在此致以衷心感谢。

 由于本人编著的水准未及专业，又忙于学业，难免挂一漏万，舛误之处，敬祈各方谅解并指正。

<div style="text-align:right">杨佳艺 博士
2017.5</div>

Editor's note

Mr. Wu is my grandfather. All paintings in this book were created by him. I admire my grandfather, for his extremely diligent and humbly studious work. He has become one of my role models that I try to emulate. As a result of his persistence, determination, and relentless pursuit of perfection, he becomes a skilled artist.

I have never engaged in editing in the past. However, for publishing this collection in the United States, I tried my best to finish all the work including editing, translating, proofreading, typesetting by myself. The pressure is huge, but I still decided to do it for my dear grandfather. Please excuse my typos/errors since I am not professional at editing, plus busy with my PhD research.

Last but not the least, the publishing of this book got help from a lot of friends. Thank you very much!

Jiayi Yang Ph.D.

2017. 5

www.ingramcontent.com/pod-product-compliance
Lightning Source LLC
Chambersburg PA
CBHW042026200526
45172CB00028B/1127